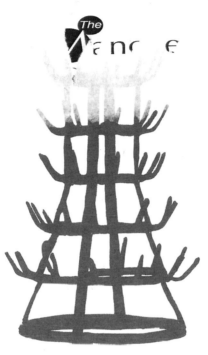

D0543093

00048599

Janis Mink

MARCEL DUCHAMP

1887–1968

Art as Anti-Art

TASCHEN

KÖLN LONDON MADRID NEW YORK PARIS TOKYO

FRONT COVER:
Fountain, 1917/1964
Fontaine
Ready-made: porcelain urinal
23.5 x 18 cm, height 60 cm
Milan, Collection Arturo Schwarz

PAGE 2:
Man Ray
Marcel Duchamp
Black and white photograph, c. 1923
Paris, Collection Lucien Treillard

BACK COVER:
Man Ray
Marcel Duchamp, 1916
Black and white photograph
Paris, Musée National d'Art Moderne,
Centre Georges Pompidou

© 2000 Benedikt Taschen Verlag GmbH
Hohenzollernring 53, D–50672 Köln
www.taschen.com
© 1994 for the illustrations of Marcel Duchamp: Alexina Duchamp, Villiers-sous-Grez
© 1994 for the illustrations of Man Ray, Matisse, Picabia: VG Bild-Kunst, Bonn
Editor and design: Burkhard Riemschneider, Cologne
Cover design: Catinka Keul, Angelika Taschen, Cologne

Printed in Germany
ISBN 3–8228–6316–5

Contents

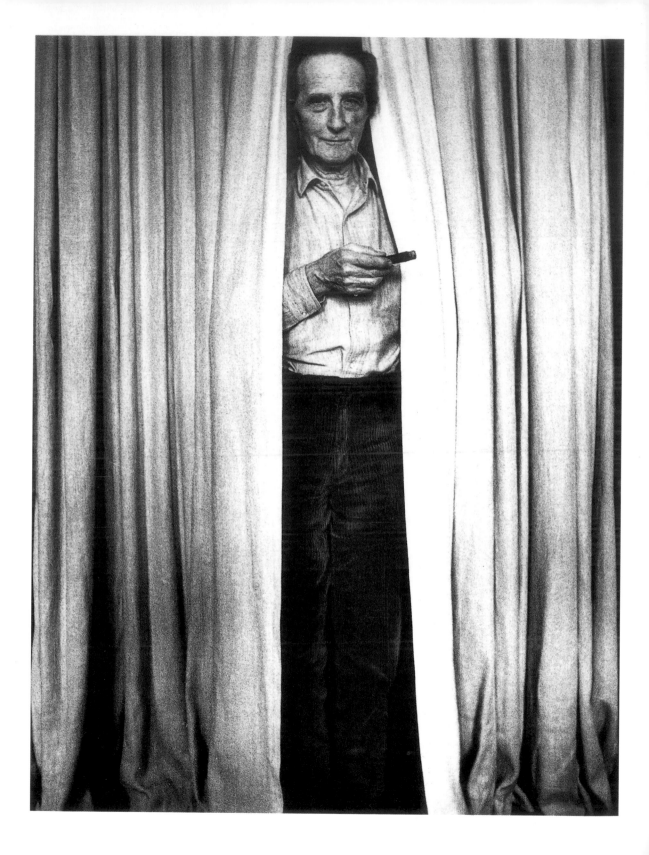

Why Not Sneeze?

Seen from today's perspective, Marcel Duchamp seems the most influential artist of the twentieth century. His critical examination of the conditions under which art is created and marketed set a trend that has continued into the present. It was Duchamp who responded most radically to the changes brought about in the art world by the industrial age. And yet Duchamp was the least spectacular of artists this century has produced to date. Although his work, due to its artistically provocative nature, received an enormous amount of critical attention, his life was surrounded by the legendary Duchamp "wall of silence". While his work already presents a kind of nerve-wracking IQ test for artists and art historians, it certainly remains an enigma to the general public. Even Duchamp's dedicated patrons were sometimes puzzled.

When asked by Katherine Dreier to produce an object for her sister, Duchamp agreed, as long as he had complete freedom. *Why Not Sneeze?* (1921, p.9), was what resulted – an assemblage of marble cubes that look like sugar lumps, a thermometer and a cuttlebone contained inside a handy old rectangular birdcage. Dorothea Dreier didn't want *Why Not Sneeze?* and gave it back to Katherine, who kept it in her collection of Duchamp's work until 1937, when she sold it without profit to another of Duchamp's main collectors, Walter Arensberg.

Why Not Sneeze? was not a success. Not many people saw it, and those who did found it hard to understand, but too strange to be meaningless. It was the kind of transitional object that channeled the hot air of Dada into the lungs of Surrealism, which was at that time just evolving. Later in 1936, *Why Not Sneeze* was even included in a Surrealist exhibition in Paris. It was placed in a showcase alongside fetishes of the Papua, as well as mathematical demonstration models from the Poincaré (scientific) Institute.

These neighboring comparisons hinted the viewer was to lift *Why Not Sneeze* out of an art context and drop it down into – what? Duchamp himself didn't help out with explanations: "This little birdcage is filled with sugar lumps... but the sugar lumps are made of marble and when you lift it, your are surprised by the unexpected weight./ The thermometer is to register the temperature of the marble."[1]

Why Not Sneeze?, with its suggestions of weight (heavy marble), promised sweetness (fake sugar cubes), missing warmth (thermometer), poetry (birdsong), arrested flight (cuttlebone and birdcage) and art (Cubism, and also the use of marble) seems to have a message for the Dreier sisters. The flippant title is a proposition. Why not do something like sneezing, that cathartic reaction that grows from a tickle to a climactic

PAGE 6:
Marcel Duchamp, 1965
Photograph by Ugo Mulas

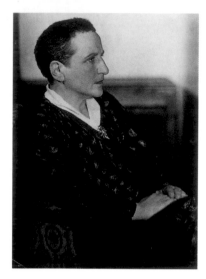

Man Ray
Gertrude Stein, c. 1926
Black and white photograph

The American writer Gertrude Stein (1874–1946) became a celebrated avant-garde personality in Paris before World War I. She collected Cézanne, Matisse and Picasso, among others. In 1933, she wrote a bestseller about her companion called *The Autobiography of Alice B. Toklas*. This prize-winning book was a great success and also made clear how significant was the role that Gertrude Stein played in Parisian literary and artistic circles. Matisse, Braque, Joyce and Hemingway were frequent visitors to her home. In 1934, she returned to the United States in order to give a series of lectures on literature and art, which probably influenced Duchamp.

explosion, leaving only runny traces behind? Duchamp's signature on the piece, his new pseudonym "Rose Sélavy", sometimes also written "Rrose", pointed in the direction of sex: Eros, C'est la vie. However, another look at *Why Not Sneeze?* makes the viewer rather guiltily try to repress that association. Could it be that the small banged-up cage, the jumble of white cubes, the glass thermometer and the brittle cuttlebone are likely to erupt?

How were the serious-minded Dreier sisters supposed to understand the piece? There were not many precedents for this kind of work in the field of visual arts. Duchamp tended to look in other directions for inspiration – to scientific models, industry or to literature. One historian finds convincing parallels between *Why Not Sneeze* and a poem by the American living in Paris, Gertrude Stein. Duchamp was familiar with Stein's writing, her role as a patron of Cubism and had even visited her with Catherine Dreier in 1916. The poem, called "Lifting Belly" (1915–1917), from which Duchamp may have taken individual elements,[2] does not contain any linear sense, but is a series of images and feelings: "Lifting belly is no joke. Not after all... Sneeze. This is the way to say it... Arrest. Do you please m..."

"I do love roses and carnations... A magazine of lifting belly. Excitement sisters... You know I prefer a bird. What bird? Why a yellow bird... Lifting belly is so kind. And so cold."

"Lifting belly marry... We do not encourage a nightingale... Can he paint? No after he has driven a car... Lifting belly is famous for recipes. You mean Genevieve... Lifting belly is sugar. Lifting belly to me..."[3]

In the poem as in *Why Not Sneeze*, the audience becomes tangled in a series of ideas that refuse to let themselves be read in a narrative fashion. Duchamp's possible references to the poem seem to be personal rather than stringent. In a sense, the viewer is lost, or turned loose within an unknown sensibility, namely that of the artist – a shaky start that has one turning about in search of orientation points.

The challenge of understanding Duchamp's work has resulted in hundreds and hundreds of interviews, books and magazine articles in many languages. It has also given birth to many more works of art. One need only turn the kaleidoscope of interpretation slightly to find that the chips of Duchamp's life and work have fallen into yet another new pattern. Duchamp himself calmly tolerated all interpretations of his art, even the most far-fetched, since he was interested in them as the creations of the people who formulated them, although not necessarily as the truth.

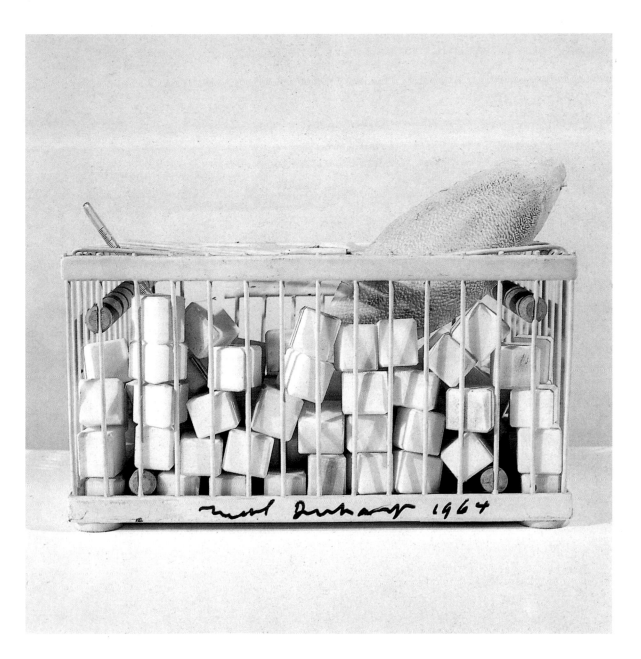

Why Not Sneeze Rose Sélavy? 1921/1964
Readymade: 152 marble cubes in the form of
sugar cubes with thermometer and cuttlefish-
bone in a birdcage
12.4 x 22.2 x 16.2 cm
Milan, Collection Arturo Schwarz

A Young Man in Spring

As the nineteenth century was creaking to an end, the Duchamp family lived in a comfortable, middle-class house near Blainville, a small town in Normandy. Mrs. Duchamp was the daughter of a shipping businessman, who was also a painter and prolific engraver. The Duchamp home was filled with his art, and he was held in high esteem both by his daughter and son-in-law and, subsequently, by his grandchildren. He was said to have studied with Charles Méryon, famous for his cityscapes of Paris. Although Mrs. Duchamp, the mother of Marcel Duchamp, had inherited her father's talent – she drew street scenes of Strasburg and Rouen for decorating porcelain crockery that was never manufactured she spent her adult married life producing and overseeing her seven children, six of whom survived and only two of whom were fond of her. Her husband was a well-to-do notary, who also became mayor of Blainville.

Both parents respected and encouraged cultural activities. The children grew up in a home where chess was played, books read, pictures painted, and where family members had mastered instruments and made music together. Yet all was not perfect. Although his father was kindly and indulgent, Marcel found his mother unresponsive and indifferent, and he was apparently hurt by this.

The two oldest children were boys, Gaston and Raymond. A little more than ten years later, after the death of a three-year-old sister, Marcel (born 28 July 1887) and Suzanne, his closest companion and playmate, followed. Around five years later, another pair of children, Yvonne and Magdeleine, their mother's acknowledged favorites, rounded off the family. While Marcel was still at school, his two older brothers gave up law and medicine to become artists, their efforts sponsored to a great extent by their father, who gradually paid out their inheritances to them in advance. Gaston moved to Paris to paint under the pseudonym of Jacques Villon. Raymond called himself Duchamp-Villon and became a sculptor. After finishing grammar school, the seventeen-year-old Marcel joined his older brothers in the autumn of 1904, moving into Jacques Villon's quarters in Montmartre. He, too, had already begun painting and drawing, as had Suzanne Duchamp also. While his sister was tied by propriety to her family, Marcel, like his brothers, was supported in his Paris endeavor by his father.

Not surprisingly, Marcel Duchamp's earliest works were sketches and paintings of the family to which he was so closely bound, and of Blainville. The lovely *Landscape at Blainville* from 1902 (p. 10), painted when he was only fifteen years old, shows his indebtedness to Monet, with whom he had become acquainted through books and reproductions and whom he admired very much at the time. Other drawings, like *Hanging*

Suzanne Duchamp Seated, 1903
Suzanne Duchamp assise
Colored pencil on paper, 49.5 x 32 cm
Milan, Collection Arturo Schwarz

Suzanne Duchamp became an artist and is known today under the family name of her second husband, Jean Crotti, who was also an artist.

PAGE 10:
Landscape at Blainville, 1902
Paysage à Blainville
Oil on canvas, 61 x 50 cm
Milan, Collection Arturo Schwarz

Gas Lamp (*Bec Auer*), c. 1902, p. 14), or the various sketches of men defined by their professions, like *Gasman* (1904–05, p. 12) or *The Knife-Grinder* (1904–05, p. 12) seem fairly unremarkable, but do show Duchamp's interest in subject-matter that does not necessarily make for a "pretty picture" and will later recur in his major work, *The Bride Stripped Bare By Her Bachelors, Even* (1915–23, pp. 74/75), also known as *The Large Glass*.

In Paris, Duchamp immediately joined the circle of artists around his brothers. He studied painting at the Académie Julian until the following summer, but preferred playing billiards to attending classes. Like his brother Jacques Villon, who supplemented his income by drawing for *Le Rire* and *Le Courrier Français*, Marcel was able to become a cartoonist and began to sell amusing drawings, most of which exhibited off-color, ribald humor, often based on visual or verbal puns. One cartoon from 1907 shows the coach of a woman hack driver (women drivers were a relatively new phenomenon at the time), who has disappeared with one of her customers into a hotel, leaving the meter running, thus charging twice for the services performed.

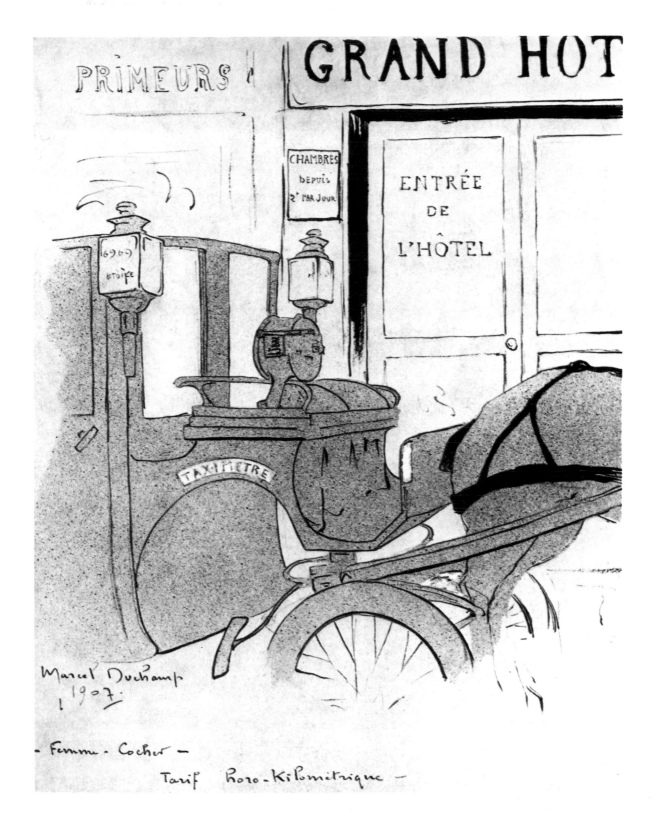

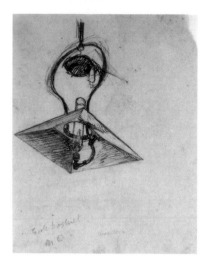

Hanging Gas Lamp (Bec Auer), c. 1902
La suspension de l'Ecole Bossuet
Charcoal on paper, 22.4 x 17.2 cm
Villiers-sous-Grez, Collection Mme Marcel
Duchamp

In 1905, Duchamp began his required military stint and received special classification (exempting him, for example, from military drill) by working for a printer in Rouen, during which time he reproduced a collection of his grandfather's etchings, with views of that city. He also became familiar with typography, since he printed text alongside the images. Since he was an "art worker", he was able to exempt himself from a second year of service. Duchamp not only enjoyed the escape from the military, he probably also appreciated the escape from "high" art into the more technical and ephemeral world of printed images.

After returning to Paris in 1906, Duchamp lived with Villon for two years before moving to Neuilly, just outside of Paris, where he remained until 1913. These were crucial years in Paris for the future of painting: the Fauves and Cubists developed the use of color and structure even further than had their predecessors, the Impressionists and Post-Impressionists. The Fauves, the most prominent of whom was Henri Matisse, used their paint often independently of their subject-matter for its own qualities of color and rhythm. Paint had become a ready-made industrial product for the Fauves. Inspired by van Gogh and Gauguin, they squished it out of tubes and applied it without regard for nature. Slightly later, the Cubists reacted against the bright colors of the Fauves and concentrated on structure. They began where Cézanne had left off, reorganizing the picture plane into geometric units. As in Fauvism, Cubism placed an emphasis on the painter's intervention into "reality": artists began recreating their subject instead of recording its appearance.

The Symbolist literary imagery of the turn of the century also continued to exert its influence, born of the writing of authors such as Stéphane Mallarmé, Edgar Allan Poe and Joris-Karl Huysmans, who expounded upon the visionary and mystical tradition in the arts. Dreams, imagination and the subconscious governed the painting of artists such as Gustave Moreau and Odilon Redon. Duchamp probably also absorbed the Symbolist view of women as threatening and mysterious creatures. When once asked early on in his career if he had used Cézanne as an inspiration, Duchamp is reported to have replied, "… if I had to say what my initial starting point was, I'd have to say it was the art of Odilon Redon."[4]

Flirt, 1907
Chinese ink, watercolour and blue pencil on
paper, 31.5 x 45 cm
Milan, Collection Arturo Schwarz

Flirt includes an inscription based on a French
pun. Duchamp toys with the term for grand
piano – "piano à queue" – and the phrase
"watery piano" – "piano aqueux": "Flirtation –
She – Would you like me to play *On the Blue
Waters*; you will see how well this piano renders the impression suggested by the title? He
(wittily) – There's nothing strange about that,
mademoiselle, it's a watery piano."

14

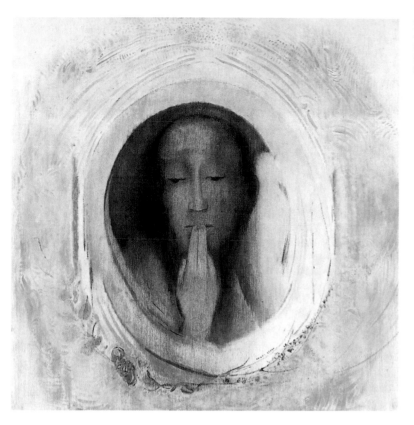

Odilon Redon
Silence, 1911
Oil on gesso and paper, 54 x 54.6 cm
New York, Museum of Modern Art,
Collection Lilli P. Bliss

Redon was not only a respected painter, but also an innovative graphic artist who was venerated in avant-garde circles around this time. His mysterious images were fed by an inner, imaginary world. They were, however, also often inspired by science, which dissected the world, so to speak, under the microscope. Perhaps most important for Duchamp may have been Redon's attitude towards his art, which was not loudly anti-academic, but rather quietly and brilliantly individual. Redon's painting *Silence* from 1911 (p. 15) almost seems to embody Duchamp's life-long non-commentary on the various interpretations of his art.

Duchamp was confronted by the styles of the day, and he tried them on for size, looking for something he felt happy with: "Between 1906 and 1910 or 1911, I vacillated between different styles and was influenced by Fauvism, by Cubism, and sometimes I also tried more classical things. Quite important for me was the discovery of Matisse in 1906 or 1907."[5] Duchamp spent the early years in Paris painting and drawing, as well as enjoying himself, as the *femme fatale* he drew for an invitation to Christmas dinner at his studio in 1907 suggests. Sketches for cartoons, such as the enticing *Flirt* (1907, p. 14) and the marital dead end *Sundays* (1909, p. 16), mark the poles between which stretched Duchamp's view of bachelor life. Even in his early twenties, Duchamp was reputed to be a confirmed bachelor, attracted to women, but repelled by marriage. "I realized quite young that one ought not to weigh oneself down with too much ballast, with too many jobs, with a wife, children, a country home, a car; luckily I realized that early on. That is why I could live much more simply as a bachelor than if I had had to deal with all of the usual prob-

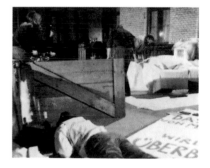

Still from the happening "The silence of Marcel Duchamp is overestimated", Düsseldorf, TV studio, 1964

During the early sixties, Duchamp proved a pervasive influence on the art world. Some artists refused to accept his work uncritically, such as Robert Smithson, who called him a reactionary priest-aristocrat, and Joseph Beuys, who, during a live performance for television in 1964, wrote a sign that said (in German) "The silence of Marcel Duchamp is overestimated".

Sundays, 1909
Dimanches
Pencil and Indian ink on paper, 60.3 x 48.6 cm
New York, The Mary Sisler Collection,
Courtesy Fourcade, Droll, Inc.

Paradise, 1910–11
Le Paradis
Oil on canvas, 114.5 x 128.5 cm
Philadelphia (PA), Philadelphia Museum of
Art: Collection Louise and Walter Arensberg

PAGE 17:
Portrait of Dr. R. Dumouchel, 1910
Portrait du Dr R. Dumouchel
Oil on canvas, 100 x 65 cm
Philadelphia (PA), Philadelphia Museum of
Art: Collection Louise and Walter Arensberg

It is hard to say why Duchamp emphasized
Dr. Dumouchel's hand. The painting might
contain a first reference to male masturbation,
which eventually became a theme of *The
Large Glass*.

lems of life."[6] (In reference to this sense of freedom, it is interesting to note here that not a single one of the six Duchamp siblings ever took on the responsibility of a child.)

During these early years, Duchamp participated in several Salon exhibitions. Because Jacques Villon belonged to the prestigious Salon d'Automne, Duchamp was able to show there as early as 1908. A year later, he exhibited for the first time at the huge Salon des Indépendants, a non-juried salon that offered no prizes and featured thousands of works from all kinds of artists. Although the Salon des Indépendants was full of amateurish painting and decorative products, its reputation as an important forum for the avant-garde had survived since the days of its founding by Odilon Redon, Paul Signac and Georges Seurat. Duchamp would later propagate its motto "No jury, no prizes" in the United States. Despite the huge number of entries in such an exhibition, Duchamp attracted a mention by the poet and critic Guillaume Apollinaire in the weary comment he formulated after a pilgrimage along the 6,000 paintings shown at the Salon des Indépendants in March 1910:

"J. Crotti has adopted pointillist theory, not in order to obtain pure tonalitiers, but simply to distinguish himself from others, to give himself a certain flair. Marinot is looking for decorative effects. Let us mention Pierre Dumont; Duchamp's very ugly nudes; Kantchalowsky, who paints with his boots; Lewitska, whose painting representing a naked couple dancing in a park is quite joyous; and let us pass on to the School of Bayzantine Revival, which includes three painters – three artisans, rather – two men and a woman: Boitchouk, Kasperowitch, and Mlle. Segno."[7]

In 1910, Duchamp was mainly interested in the work of the Fauves, as the portrait of his school friend Dr. Dumouchel shows (p. 17). Duchamp

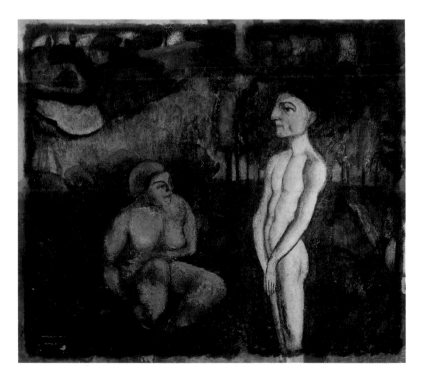

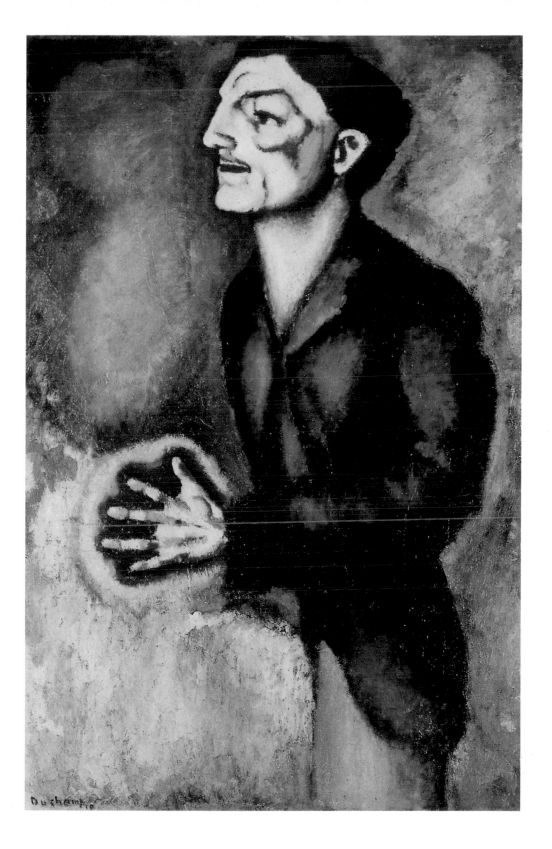

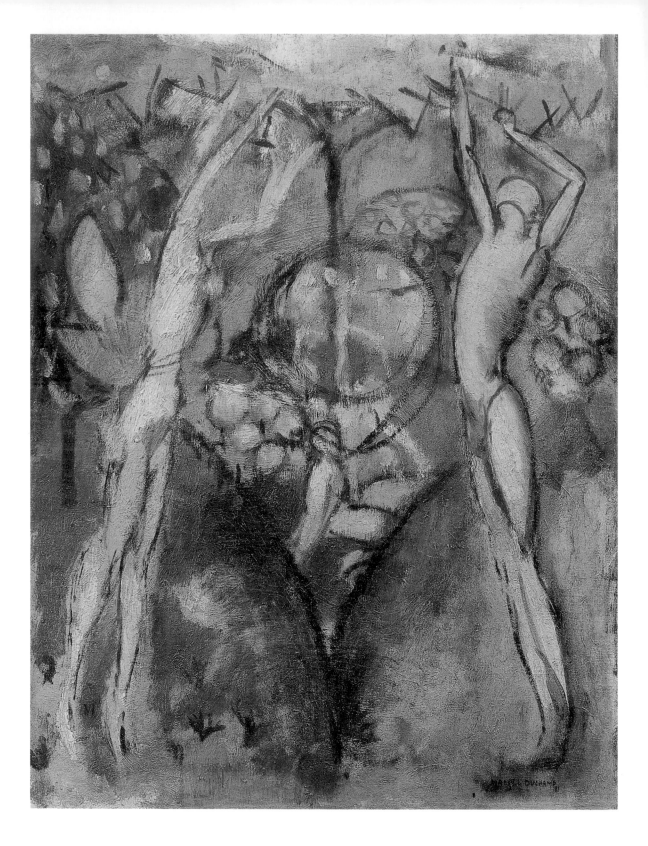

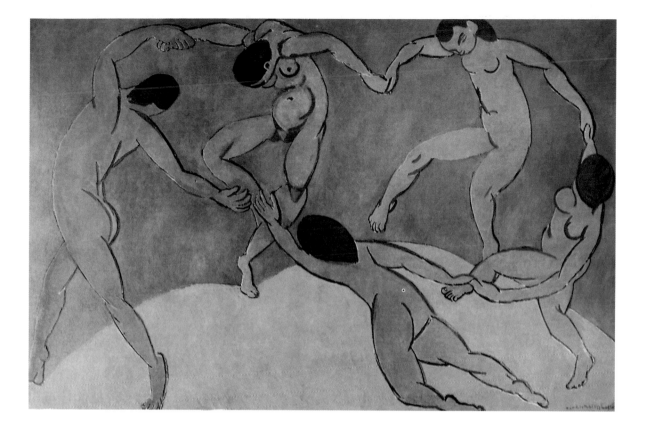

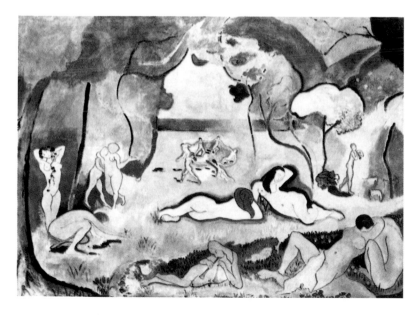

Henri Matisse
The Dance, c. 1910
La danse
Oil on canvas, 260 x 391 cm
St. Petersburg, Hermitage. Formerly Collection Sergei Shchukin

Henri Matisse
The Joy of Life, 1905–06
La joie de vivre
Oil on canvas, 174 x 238 cm
Merion (PA), Barnes Foundation, Merion
Station. Formerly Collection Leo Stein,
Christian Tetzen-Lund

Young Man and Girl in Spring, 1911
Jeune homme et jeune fille dans le printemps
Oil on canvas, 65.7 x 50.2 cm
Milan, Collection Arturo Schwarz

commented on the painting, "It reminds one of Van Dongen's violent coloring and at the same time, details, like the haloed hand, indicate my definite intention to add a touch of deliberate distortion. The composition is completely not at all a servile copy of the model, it becomes almost a caricature."[8] Perhaps Duchamp was even thinking of Rembrandt's famous portrait of Dr. Tulp, whose left hand also seems to have an eloquent, symbolic quality. Dr. Dumouchel turns up again as an ugly nude in the male/female subject matter of *Paradise* (1910–11, p. 16). The doctor wilfully ignores the crouching nude woman across from him, yet he does not appear at ease, for he shamefully covers his genitals, looking less like a sinful Adam than a skinny, inadequate contemporary. The female model for Eve was quite stocky, which Duchamp more or less faithfully reproduced.

However, in *Young Man and Girl in Spring* (1911, p. 18), Duchamp stretched and idealized his figures, as if he were drawing very young people – they resemble abstract sketches of his sister Magdeleine and sketches and paintings of Jeanne Serre, an artist's model who bore Duchamp a daughter. (This daughter met her real father only two years before his death in 1968.) Again, the theme of paradise is shown, here at the very moment before it is lost. Both figures remain anonymous. The woman's head is tipped back so that we only see the dark crown of her head, while the man's features have been omitted in favor of his chin line. The woman's identity as hair and the man's as chin is predictably specific to their sexes, which are clearly silhouetted, although not emphasized. Indeed, at first glance the two figures almost seem to be identical and androgynous. They are standing under an arbor, joined overhead by the crown of the tree whose fruit they are trying to reach. Its trunk separates them and echoes the verticality of their stretching young bodies.

Up to now, attention has never been paid to the fact that at least five additional figures are crowded into the middle of the painting. Within the

The game of chess in Pasadena Art Museum on 18 October 1963, during the first comprehensive retrospective of Duchamp's works. Photograph by Julian Wasser

Besides being a lifelong passion, chess was a symbolic activity for Duchamp. During the opening of the Duchamp retrospective in Pasadena, California in 1963, Duchamp had himself photographed playing chess with an anonymous naked woman. The central *Large Glass* can be seen clearly in the background. Duchamp appears to the right, while the woman is seated to the left, similar to the figures in *Young Man and Girl in Spring* (p. 18).

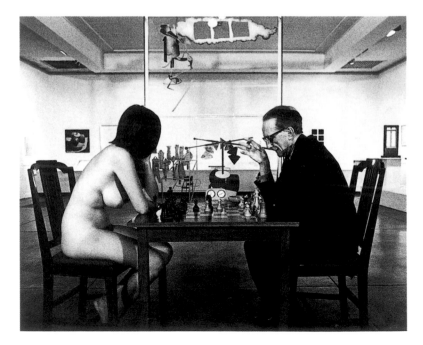

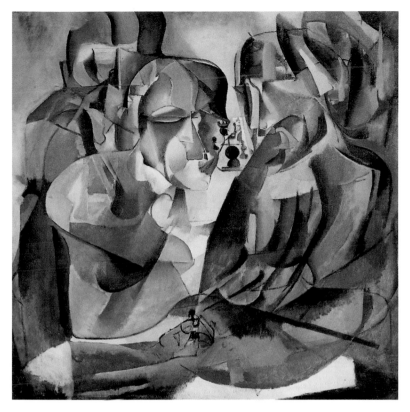

Portrait of Chess Players, 1911
Portrait de joueurs d'échecs
Oil on canvas, 108 x 101 cm
Philadelphia (PA), Philadelphia Museum of
Art: Collection Louise and Walter Arensberg

Yvonne and Magdeleine Torn in Tatters, 1911
Yvonne et Magdeleine déchiquetées
Oil on canvas, 60 x 73 cm
Philadelphia (PA), Philadelphia Museum of
Art: Collection Louise and Walter Arensberg

PAGE 22:
Sonata, 1911
Sonate
Oil on canvas, 145 x 113 cm
Philadelphia (PA), Philadelphia Museum of
Art: Collection Louise and Walter Arensberg

PAGE 23:
Dulcinea, 1911
Dulcinée
Oil on canvas, 146 x 114 cm
Philadelphia (PA), Philadelphia Museum of
Art: Collection Louise and Walter Arensberg

Sad Young Man in a Train, 1911
Jeune homme triste dans un train
Oil on canvas, affixed to cardboard,
100 x 73 cm
Venice, Peggy Guggenheim Foundation

circle in the center of the picture is a group of dancers who appear to be
holding hands, very much like the small circle of dancers in the center
background of Matisse's painting *The Joy of Life* (1905–06, p. 19). *The
Joy of Life* was an important source even for Matisse himself, who de-
veloped other large compositions from it, such as *The Dance* of 1910
(p. 10). One of Duchamp's figures is seated under the circle, whose black
outlines break loose and rope down over it. Again, Matisse's pastoral
nudes may appear in translation here. Duchamp must have used many
other details from Matisse as well, such as the segmenting black lines,
the roughly triangular composition and the roof of tree-tops. Later, in the
last work of Duchamp's life, *Etant donnés* (pp. 85–89), Matisse's female
figures will come back to mind. Some of Duchamp's related torsos will
recall the energy and spread legs of Matisse's dancers, while the final

three-dimensional torso of *Etant donnés* (p. 87) will resemble the heavy, "headless" kissing female figure in the lower right-hand corner of *The Joy of Life*.

The small *Young Man and Girl in Spring* (p. 18) is a little muddy in spots and hard to decipher. Strangely enough, the owner of this painting, Arturo Schwarz, who worked closely with Duchamp as a gallery-owner and assembled the œuvre catalogue of his work, interprets the circle as containing only a single figure. This opinion has never been contradicted. However, the inclusion of a ring of dancers suggesting joy would be logical, since Duchamp painted *Young Man and Girl in Spring* for his sister Suzanne as a wedding gift and signed it "A toi ma chère Suzanne Marcel". The inclusion of Matisse's *The Joy of Life* (p. 19) would have been an appropriate (if not entirely heartfelt) wish that the painter Suzanne Duchamp could have recognized and appreciated, even if her husband, a pharmacist, probably could not. As one of life's rites of passage, his younger sister's wedding may have been a touching or difficult experience for Duchamp, although he never discussed this. Yet it seems that Duchamp's preoccupation with transition, change, movement and distance began around this time.

Towards the end of 1911, Duchamp would sometimes visit his brothers and František Kupka in Puteaux, across the Seine to the west of Paris. There he met, played chess and discussed art with Fernand Léger, Roger de la Fresnaye, Albert Gleizes, Jean Metzinger, Juan Gris and Alexander Archipenko. One day, Raymond Villon-Duchamp asked a few of his friends, as well as Duchamp, to paint small works to decorate his kitchen. As an appropriate gift for the kitchen, Duchamp painted him a small *Coffee Mill* (p. 25) grinding away (see arrow), but also breaking apart and spilling its coffee; it was his first "machine", a bit funny and out of kilter. In 1911, Duchamp also executed several portraits of girls and women that reflected his loose, perhaps not entirely respectful contact with members of the Cubist group: *Yvonne and Magdeleine Torn in Tatters* (p. 21), a painting of his youngest sisters, *Sonata* (p. 22), showing his mother and three sisters, and *Dulcinée* (p. 23). Dulcinée was a woman who remained unknown to Duchamp, but who he sometimes observed walking her dog in Neuilly. He has stripped her bare in two of the figures, which all roughly unite to a kind of faceted vase form, where the torsos poke out like thick stems with flower-heads. Although an erotic scene, there is nothing erotic-looking in the final product, and Dulcinée, for all her walking back and forth, has become something of a still life. Clearly Duchamp was interested in motion as described by its static phases. The cinema and analytic time photography (photochronographs) by Marey in France, and Eakins and Muybridge in the United States, inspired him.

Sad Young Man in a Train (p. 24), painted in December 1911, is a self-portrait of Duchamp standing in the corridor of a train, on a trip from Paris to Rouen, where his parents and sisters had moved in 1905. "There are two aspects to this painting. One is the movement of the train, and the other is the sad young man standing in the corridor and walking back and forth, so that we have two parallel movements which correspond to one another. In addition, there is the deformation of the young man's shape, which I used to call elementary parallelism. It is a kind of formal decomposition, a fanning out into linear panels that run parallel to each other and deform the subject. Thus he is stretched as if he were elastic. The lines run parallel to each other and change only slightly to suggest the desired form. I used the same method in *Nude Descending a Staircase*."[9]

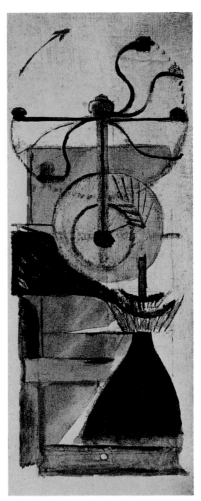

Coffee Mill, 1911
Moulin à café
Oil on cardboard, 33 x 12.5 cm
Rio de Janeiro, Collection Mrs. Robin Jones

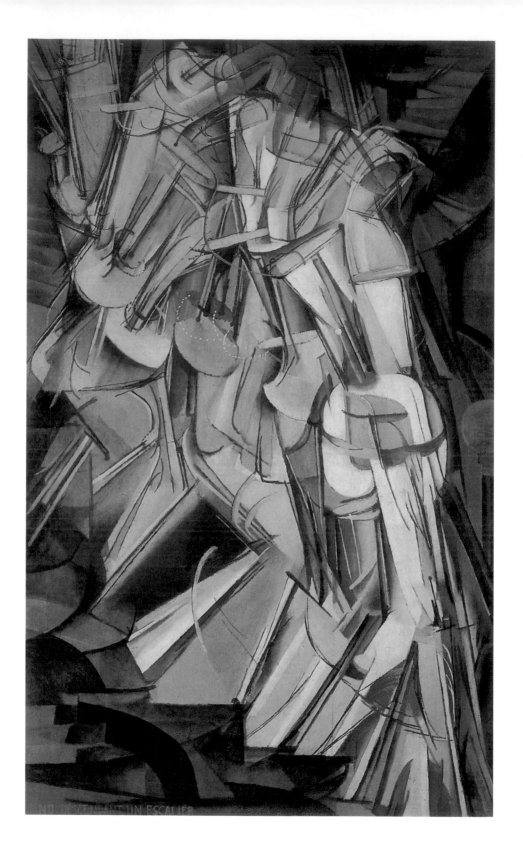

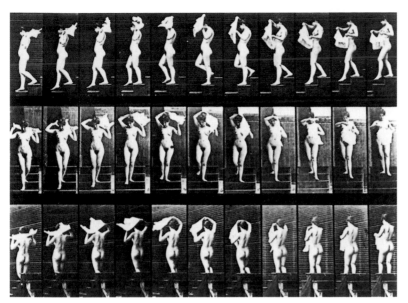

Eadweard Muybridge
Human Locomotion, Panel 616, 1887
Photograph, 22 x 33 cm
New York, Collection Timothy Baum

The photographer Eadweard Muybridge put single, separately timed images together in a series in order to make the phases of motion visible. Muybridge enabled dynamic processes in humans and animals to be perceived in a manner that approximated reality, as did also the physiologist Etienne-Jules Marey. Influenced by such photographic analyses of reality, the Italian Futurists began to make "moving pictures".

Nude Descending a Staircase (No. 2) of 1912 (p. 26) was the painting that changed Marcel Duchamp's life. Like the sad young man, this "nude" was a more radical and mechanized version of the anonymous figures from *Young Man and Girl in Spring* (p. 18). The figure hardly looked nude because it hardly looked human. When Duchamp submitted it to the Salon des Indépendants, it was coldly received. The Cubist painter and theorist Albert Gleizes, who belonged to the hanging committee, asked Duchamp's brothers, Jacques Villon and Raymond Duchamp-Villon, to have him "voluntarily" withdraw it. It did not conform to what the Cubist circle wanted for their representative exhibition. It seemed too "Futurist" to them, since it contained movement. The Cubists wanted to clarify and strengthen their position against other "isms" that were cropping up. Embarrassed and serious, the elder brothers asked Duchamp to concede, which he did without making a fuss. However, he was hurt. "[This affair] helped me to totally escape the past, my own personal past. I said to myself, 'Well, if that's the way they want it, then there's no question about me joining a group; one can only count on oneself, one must be a loner.'"[10]

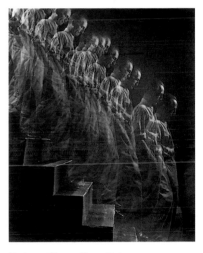

Duchamp Descending a Staircase
LIFE MAGAZINE, No. 284, New York 1952
Photograph by Eliot Elisofon

PAGE 26:
Nude Descending a Staircase (No. 2), 1912
Nu descendant un éscalier n° 2
Oil on canvas, 146 x 89 cm
Philadelphia (PA), Philadelphia Museum of
Art: Collection Louise and Walter Arensberg

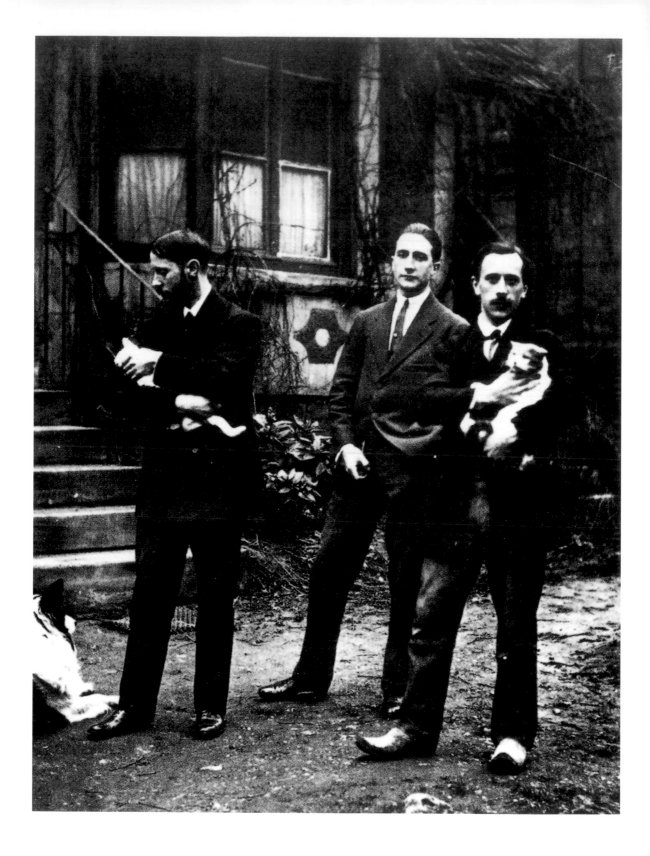

On a Train of Thought

In 1912, Marcel Duchamp turned twenty-five years old; he was nearly at the end of his career as a painter. During this year, one of immense change, he was to begin traveling more, looking for inspiration outside of the familiar Parisian art circles, and even outside of the visual arts as a whole. Several writers were to be of particular importance, especially those who had begun to experiment with language.

In October of 1911 at the Salon d'Automne, he had become acquainted with Francis Picabia, who introduced him to a new kind of life outside of the stolid circle of professional artists at Puteaux. Picabia became a good friend and would remain one all his life. Duchamp felt drawn to this innovative man after the disappointment with his elder brothers and the established Cubists. In June of 1912, Duchamp attended a theater performance with Picabia, Picabia's wife, Gabrielle Buffet-Picabia, and Apollinaire. It was an experience that was to decisively change the whole of his art: a stage adaptation of Raymond Roussel's novel *Impressions d'Afrique* (first published in 1910). Years later, in an important interview with James Johnson Sweeney, Duchamp said:

"Roussel was another great enthusiasm of mine in the early days. The reason I admired him was because he produced something I had never seen. That is the only thing that brings admiration from my innermost being – something completely independent – nothing to do with the great names or influences. Apollinaire first showed Roussel's work to me. It was poetry. Roussel thought he was a philologist, a philosopher and metaphysician. But he remains a great poet.

It was fundamentally Roussel who was responsible for my glass, *The Bride Stripped Bare By Her Bachelors, Even* (pp. 74/75). From his *Impressions d'Afrique* I got the general approach. This play of his which I saw with Apollinaire helped me greatly on one side of my expression. I saw at once that I could use Roussel as an influence. I felt that as a painter it was much better to be influenced by a writer than by another painter. And Roussel showed me the way.

My ideal library would have contained all of Roussel's writings – Brisset, perhaps Lautréamont and Mallarmé. Mallarmé was a great figure. This is the direction in which art should turn: to an intellectual expression, rather than to an animal expression. I am sick of the expression 'bête comme un peintre' – stupid as a painter."[11]

Roussel's image-laden writing is extremely difficult to follow, since the plot spirals in on itself, becoming more and more complex, or perhaps one should say his stories implode, creating entire universes of detail. Roussel arrived at his ideas by using homophones – words that

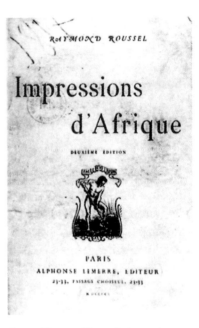

Cover of Raymond Roussel's *Impressions d'Afrique*, first edition 1910, Paris, Bibliothèque Nationale.

Raymond Roussel (1877–1933) was a poet, actor, dandy and millionaire. In his novels he combined radically fantastic subject-matter with a distanced, morbid style. He was an important forerunner of Surrealism, due to the special method of (free) association he used to write his books.

PAGE 28:
Jacques Villon, Marcel Duchamp and Raymond Duchamp-Villon in Puteaux, 1912
Milan, Collection Arturo Schwarz

sound alike but have different meanings and origins. He chose the words at random. For example, "empereur" became the three words "hampe" (pole), "air" (wind), and "heure" (hour), which inspired "the windclock of the land of Cockaigne". Another example: "étalon à platine", which could mean "standard meter in platinum" or "stallion with the gift of the gab".[12] Obviously, this could end in startling imagery for a stage production, since Roussel was using the phonic projection of a phrase to throw a shadow that he traced and gave a new identity. In a theater publication of the period, a photograph shows the actors from *Impressions d'Afrique* during Act III. They surround a glass cage, which is on a table. It has the rhyming caption "Le ver de terre joueur de Cithare" (more or less, "The earthworm player of the zither").[13] Supposedly, the earthworm's mercury-containing secretions struck the chords of the instruments and so produced music – an idea that is arbitrary, absurd, but logical from the point of phonetic grouping. Of course, if "earth", "player" and "zither" didn't rhyme in French, the image would never have existed in the first place. Perhaps the glass cage contained a snake instead of a worm; Duchamp, at least, remembered one: "On the stage were only a window display dummy and a snake that moved slowly; it was the absolute height of unusualness."[14] One of Duchamp's notes for *The Large Glass* under the heading "General notes for a hilarious picture" was "put the whole bride under a glass case, or into a transparent cage."[15] After seeing the play, ideas began to collect that would slowly bring forth the staging of the bride and her bachelors.

Alongside human characters, Roussel introduced at least partially humanoid machines that could do things like fence or paint. An uncannily agile fencing machine "consisted of a kind of grinding wheel, which,

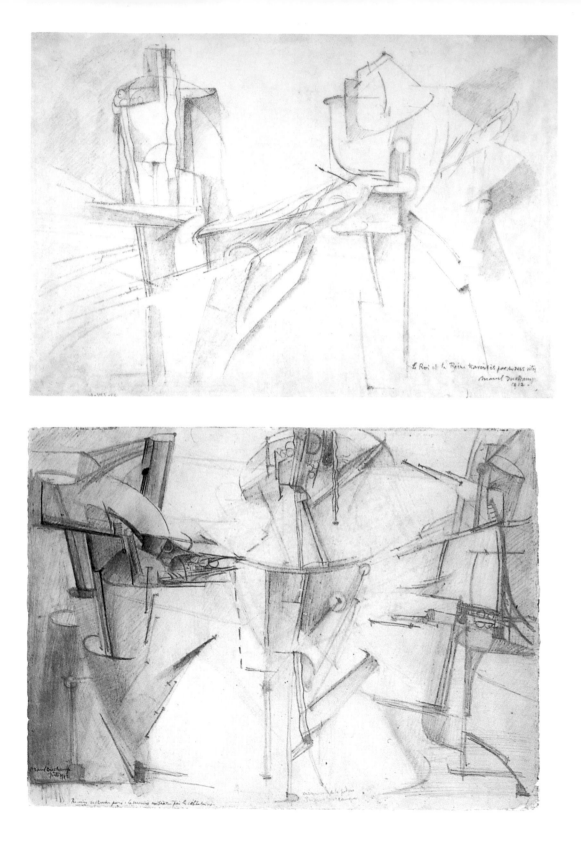

powered by a pedal, could move an entire system of wheels, connecting rods, levers and springs, forming an undecipherable metallic tangle; on one side protruded a membered arm that ended in a hand holding a foil."[16] Such a description also almost seems to fit the sad young man on a train that Duchamp had just painted. Roussel's inventive machinery, his artificial scientific experiments and his perversion of sense in order to create new meanings infected Duchamp's imagination. In addition, specific ideas from Roussel's books recur periodically in Duchamp's art, such as an apparently light statue that later proves to be heavy, (by sculptor Montalscott in Roussel's *Locus Solus* of 1914), an apparatus that can make an artwork using only the combined effects of weather (the Demoiselle in *Locus Solus*) or a corporation formed to finance a game of chance (in *Impressions d'Afrique*).

In the wake of *Impressions d'Afrique*, Duchamp began to "write". He scribbled short notes to himself onto scraps of paper or the backs of gas bills, sometimes augmenting them with hurried sketches. These fragmentary ideas were saved, and would serve as a source for *The Large Glass* (pp.74/75). (Duchamp later published the notes – or at least part of them – in facsimile form.) In addition, Duchamp continued to invent longer and more enigmatic titles that pointed beyond his works themselves, although it is not quite clear at what. Ironically, it is the length of Duchamp's titles that now leads them to being shortened for purposes of discussion. For example, his main early work, *The Bride Stripped Bare By Her Bachelors, Even* is often simply called *The Large Glass*.

After having become acquainted with Roussel's work, Duchamp planned a trip to Germany to visit a friend of his that he had first met in Paris two years before. He spent most of his three-month trip in Munich. "In those days I would have gone anywhere. Me going to Munich came about because I had met a cow painter in Paris – I mean a German, who painted cows, the best cows naturally, an admirer of Lovis Corinth and all those people –, and when this artist said, 'Go to Munich' I got up and went there and lived for months in a small furnished room. There were two cafés where the artists went. Kandinsky's book [*On the Spiritual in Art* (*Über das Geistige in der Kunst*), published in 1912 in Munich], was in all of the stores and one could see paintings by Picasso in a gallery on Odeonsplatz."[17] Duchamp had taken German in school and could at least understand the language. Once he even mentioned a German phrase in his notes, and a first edition copy of *On the Spiritual in Art*, with annotations in it probably made by Duchamp, was found in the library of Jacques Villon.

Duchamp never borrowed from Kandinsky, but he must have agreed with his condemnation of the art market and the inflation of painting. Kandinsky managed to sum up the problems against which Duchamp was beginning to react: "With a greater or lesser degree of facility, virtuosity and brio, objects are given life upon the canvas, which belong to coarser or finer categories of 'painting'. The harmonization of the whole upon the canvas is the path that leads to the work of art. This work is observed with cold eyes and indifferent spirit. Connoisseurs admire the 'technique' (just as one admires a tightrope walker), enjoy the *'peinture'* (just as one enjoys *pâté*).

Hungry souls go away hungry.

The great masses wander through the rooms, find the canvases nice or great. The man who could have said something to his fellow man has said nothing, and he who might have heard has heard nothing.

This condition of art is called *l'art pour l'art* …

PAGE 32 ABOVE:
The King and Queen Traversed by Swift Nudes, 1912
Le roi et la reine traversés par des nus vites
Pencil on paper, 27.3 x 39 cm
Philadelphia (PA), Philadelphia Museum of Art: Collection Louise and Walter Arensberg

PAGE 32 BELOW:
The Bride Stripped Bare by the Bachelors, 1912
La mariée mise à nu par les célibataires
Pencil and gouache on paper, 23.8 x 32.1 cm
Paris, Musée National d'Art Moderne, Centre Georges Pompidou

Box of 1914, 1914
Boîte de 1914
Cardboard box with facsimiles of 16 handwritten notes and a drawing, each 25 x 18.5 cm
Philadelphia (PA), Philadelphia Museum of Art: Gift of Mme Marcel Duchamp

To Have the Apprentice in the Sun, 1914
Avoir l'apprenti dans le soleil
Chinese ink and pencil on music-paper,
27.3 x 17.2 cm
Philadelphia (PA), Philadelphia Museum of Art: Collection Louise and Walter Arensberg

The artist seeks material rewards for his skill, his powers of invention and observation. His aim becomes the satisfaction of his own ambition and greed. Instead of a close collaboration among artists, there is a scramble for these rewards. There are complaints about competition and overproduction. Hatred, bias, factions, jealousy and intrigue are the consequences of this purposeless, materialist art."[18]

Little is known of Duchamp's time in Munich, but since his friend was intent on showing him the sights as well as acquainting him with the night-life, he may have seen or heard of other theater productions, such as the reviews of Frank Wedekind, a provocateur who exploited sexuality for his appearances. Wedekind's standard first line to young women was "Are you still a virgin?" He would even urinate and masturbate on stage.[19] This was the spirit that would eventually evolve into Dada performance. Duchamp never mentioned being influenced by Wedekind, but the latter was a darling of the artistic community in Munich at the time. It is known that Duchamp did the cultural "musts" and visited scenic places. He was in the area of Neufahrn, for example, where the church is associated with Saint Wilgefortis, an early Christian virgin princess who refused to marry and miraculously grew a beard when stripped, as Christ was, by her executioners.[20] While in Germany, Duchamp certainly spent much time in the museums, admiring particularly the tall nudes by Lucas Cranach. Perhaps he even saw some paintings on glass that were a special form of Bavarian folk art and inspired Kandinsky and his circle to paint similar small format pictures.

In any case, it was in Munich that Duchamp began formulating his ideas for his major work, *The Bride Stripped Bare By Her Bachelors, Even* (pp. 74/75). Duchamp executed several important oil paintings that began to blend sexuality with transition and the movement of machinery. One preliminary sketch, *The Bride Stripped Bare by the Bachelors* (p. 32 below), shows a figure in the center being attacked by two other figures to its right and left. Lines suggest aggressive and violent motion. Next

Glider Containing a Water Mill in Neighboring Metals, 1913–15
Glissière contenant un moulin à eau (en métaux voisins)
Oil and semicircular glass, lead, lead wire, 147 x 79 cm
Philadelphia (PA), Philadelphia Museum of Art: Collection Louise and Walter Arensberg

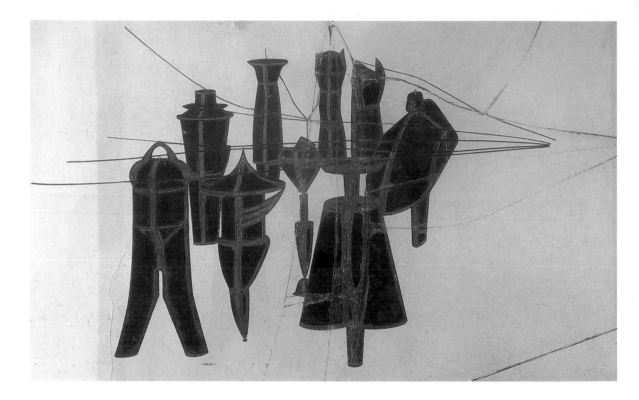

ABOVE:
9 Malic Molds, 1914–15
9 moules mâlic
Oil, lead wire, lead foil on glass between two glass plates, 66 x 101.2 cm, replica by David Hamilton 1966
Milan, Collection Arturo Schwarz

Cemetery of Uniforms and Liveries (No. 1), 1913
Cimitière des uniformes et livrées (n° 1)
Pencil on paper, 32 x 40.5 cm
Philadelphia (PA), Philadelphia Museum of Art, Collection Louise and Walter Arensberg

Duchamp explored the idea of the virgin in two drawings, which he developed into the painting *The Passage from Virgin to Bride*, a beautifully flesh and earth-colored composition. A vertical mechanical being with a head, a spine, a pelvis and legs "moves" from left to right in a poetic or metaphysical sense: "a passage in my life of painting…"[21] Duchamp painted *The Passage from Virgin to Bride* partly with his fingers, and its surface is velvety and elegant in warm tones of brown, ochre and coral against a dark background that gives the work an Old Master flavor. Apparently, German religious paintings from the Middle Ages and Renaissance had made an impression on him, and he borrowed flesh tones from Cranach. Again, one sees the strange combination of visceral and mechanical forms that are important to Duchamp: long, thin columns connecting areas of volume and breaking at points into funnels, hinges and segments as if to suggest manufactured parts. Pipe-like lines of approximately equal length are repeatedly set as accents and directing forces.

After returning from Munich in October, Duchamp was to set off on another trip, this time in an automobile with Francis Picabia, Gabrielle Buffet-Picabia and Guillaume Apollinaire. It led the group through the Jura mountains, but the journey was also an intellectual one that might be described, in the words of Buffet-Picabia, as one of their "forays of demoralization, which were also forays of witticism and clownery… the disintegration of the concept of art".[22] The notes Duchamp wrote during this trip played with language. He avoided expected logic and sense, yet maintained an absolutely serious, even explanatory tone. The notes are worth quoting here at length to illustrate just how far Duchamp had distanced himself from recording reality, instead developing new "ugly" qualities such as repetition and frustration.

"The chief of the 5 nudes extends little by little his power over the Jura-Paris road. There is a little ambivalence: After having conquered the 5 nudes, this chief seems to enlarge his possessions, which give a false meaning to the title. (He and the 5 nudes form a tribe for the conquest by speed of this Jura-Paris road.) The chief of the 5 nudes increases little by little his power over the Jura-Paris road. The Jura-Paris road, on the one side, the 5 nudes one the chief, on another side, are the two terms of the collision. This collision is the raison d'être of the picture. To paint 5 nudes statically seems to me without interest, no more for that matter than to paint the Jura-Paris road even by raising the pictorial interpretation of this entity to a state entirely devoid of impressionism. Thus the interest in the picture results from the collision of these 2 extremes…"[23]

At other moments, Duchamp almost seems to be interpreting visual impressions of his speeding through the countryside into an absurdly romantic hypothesis:

"This headlight child could, graphically, be a comet, which would have its tail in front, this tail being an appendage of the headlight child appendage which absorbs by crushing (gold dust, graphically) this Jura-Paris road…

This headlight will be the child-God, rather like the primitive's Jesus. He will be the divine blossoming of this machine-mother. In graphic form, I see him as a pure machine compared to the more human machine-mother. He will have to be RADIANT WITH GLORY. And the graphic means to obtain this machine-child, will find their expression in the use of the purest metals for a construction based… on the concept of an endless screw,… serving to unite this headlight child-God, to his machine mother, 5 nudes."[24]

Page from *Manufacture… de Saint-Étienne*, from the year 1913, a famous French specialist catalogue for weapons and bicycles

The viewer is struck by the similarity between Duchamp's bachelors and illustrations in contemporary fashion catalogues. There are definite correspondences between the forms Duchamp uses in *9 Malic Molds* and such illustrations dating from the early twentieth century, showing that he was obviously inspired by them.

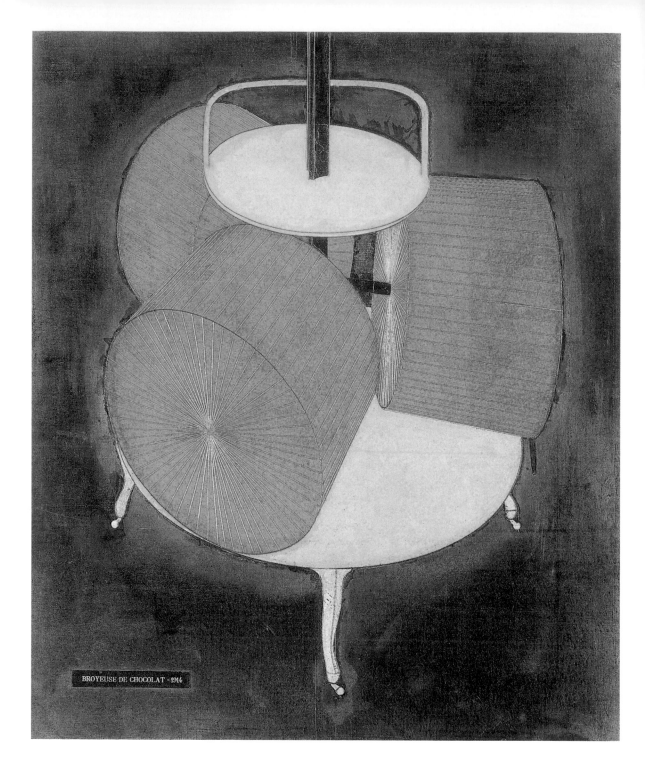

BROYEUSE DE CHOCOLAT - 1914

Study for the **Chocolate Grinder No. 2**,
1914
Etude pour la *Broyeuse de chocolat n° 2*
Oil and pencil on canvas, 73 x 60 cm
Düsseldorf, Kunstsammlung Nordrhein-
Westfalen

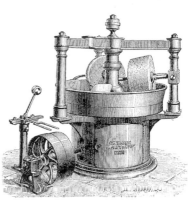

Chocolate grinder, illustration from a cata-
logue, c. 1920
Duchamp's composition is obviously based on
a functional machine, as was used at that time.

PAGE 38:
Chocolate Grinder No. 2, 1914
Broyeuse de chocolat n° 2
Oil and thread on canvas, 65 x 54 cm
Philadelphia (PA), Philadelphia Museum of
Art: Collection Louise and Walter Arensberg

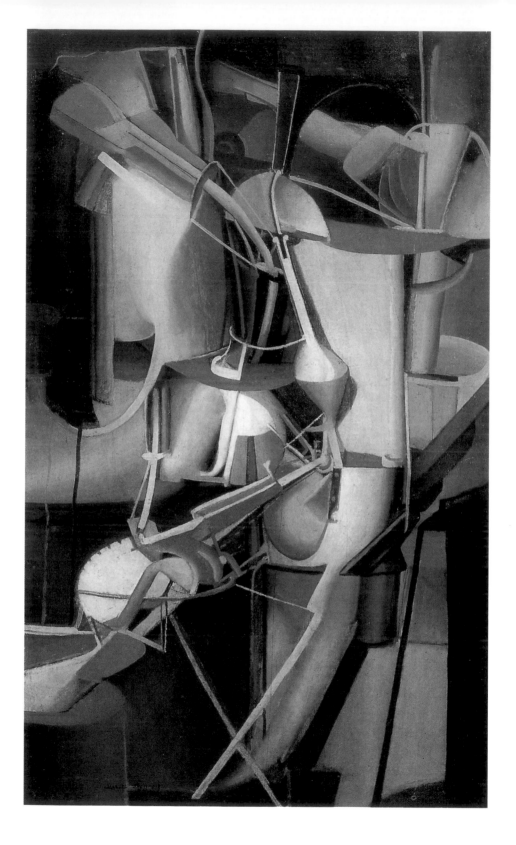

Man Ray
Francis Picabia, 1923
Black and white photograph

There is no way of knowing just what Duchamp is camouflaging in this thicket of detail. His identification with the headlight child is indicated years later when he sported a haircut with a star-shaped comet shaved into the hair on the back of his head, its tail baring his scalp towards the front. This must have seemed an eccentric gesture, since at this time the above text had not been published. But as with Roussel, there is some invisible rule guiding Duchamp's output. Sentience, not nonsense, is lurking behind the mechanics.

Probably that same year, in 1912, Fernand Léger reports that he, Constantin Brancusi and Duchamp visited an exhibition of aviation technology together, and that Duchamp turned to his good friend Brancusi and said, "Painting is washed up. Who will ever do anything better than that propeller? Tell me, can you do that?"[25] Such a statement clearly shows the visual artist's dilemma when faced with the accomplishments of the developing industrial age and their intrusions into everyday life. Oil paintings had become history. After his automobile trip with Duchamp and Picabia, Apollinaire wrote: "Just as Cimabue's pictures were paraded through the streets, our century has seen the airplane of Blériot, laden with the efforts humanity made for the past thousand years, escorted in glory to the (Academy of) Arts and Sciences. Perhaps it will be the task of an artist as detached from aesthetic preoccupations, and is intent on the energetic as Marcel Duchamp, to reconcile art and the people."[26]

And in a way, Apollinaire was right, because Duchamp was to begin metamorphosing painting into a product of the living structures of the twentieth century.

PAGE 40:
Bride, 1912
Mariée
Oil on canvas, 89.5 x 55.25 cm
Philadelphia (PA), Philadelphia Museum of
Art: Collection Louise and Walter Arensberg

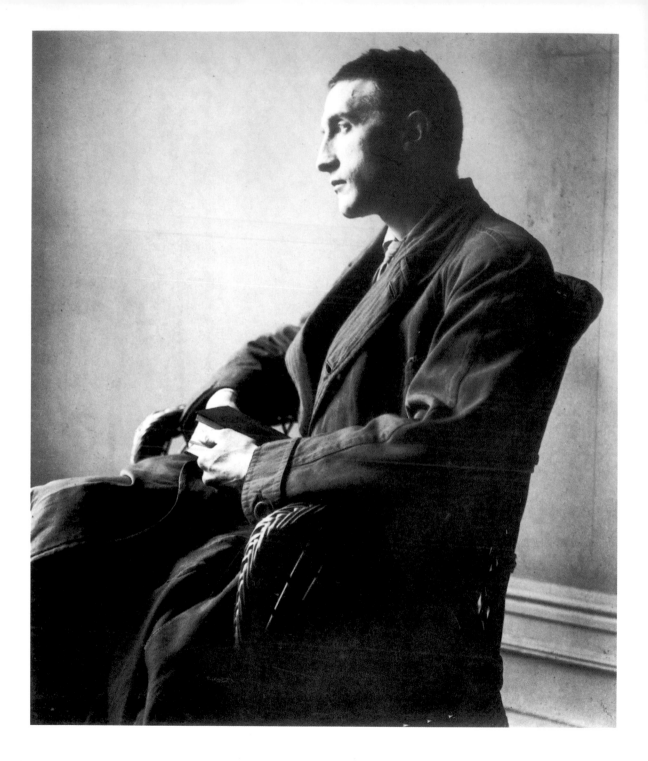

Breaking Free

Towards the end of 1912, Picabia used his connections to secure Duchamp a librarian job in the Bibliothèque Sainte-Geneviève, where he worked until May 1914. Duchamp was not only able to earn a small hourly wage there, he could also withdraw from painting circles into the realm of the scholar. He pursued subjects like mathematics and physics, in which discoveries had been made that had recently shaken the foundations of scientific thought. They were being heatedly discussed in artistic and intellectual circles at the time, and were understood and applied with varying degrees of precision.

The author most important for Duchamp's development was the mathematician and physicist Henri Poincaré, who published several theoretical books during the first decade of the twentieth century. The books describe conceptual changes that occurred with the discovery of X-rays, the phenomenon of radioactivity, of radium and especially of the electron and its laws. In his concise book about Duchamp, the art historian Herbert Molderings has clearly described Poincaré's importance for the epoch and for Duchamp, who began to use a playful, skeptical brand of physics to devalue rational science:

"All views on matter, its structure and motion had to undergo a revision. Physics had entered a stage of development that Poincaré characterized as a 'general breakdown of principles', as a 'period of doubt' and 'serious crisis' in science. The essence of this crisis was not only the disintegration of old physical laws and axioms, but rather in the fundamental doubt as to the possibility of objective scientific knowledge. Materialism, which formed the basis of the sciences in the nineteenth century, was replaced by the philosophy of idealism and agnosticism... The philosophy of agnosticism, which will predominate in modern science, there, where the masses of humanity supposed it to consist of firm insights, will form the crux of Duchamp's new art."[27]

Poincaré explained that the laws believed to govern matter and its behavior were created solely by the minds that "understood" them. No theorems could be considered true. "The things themselves are not what science can reach..., but only the relations between things. Outside of these relations there is no knowable reality."[28] Although Duchamp himself did not say so, this sentence of Poincaré's could be considered a leitmotif for the rest of the artist's life. No single work of art he made from this point on was meant to stand alone. All of his works echo, reflect and project each other like Roussel's homophones. The tantalized art historian cannot reach a definitive stand, because there is no final position in the relationships among the things Duchamp made and said. Several of

The Bibliothèque Sainte-Geneviève in Paris, where Duchamp was employed in 1913 as a librarian.

PAGE 42:
Man Ray
Marcel Duchamp, 1916
Black and white photograph
Paris, Musée National d'Art Moderne, Centre Georges Pompidou

43

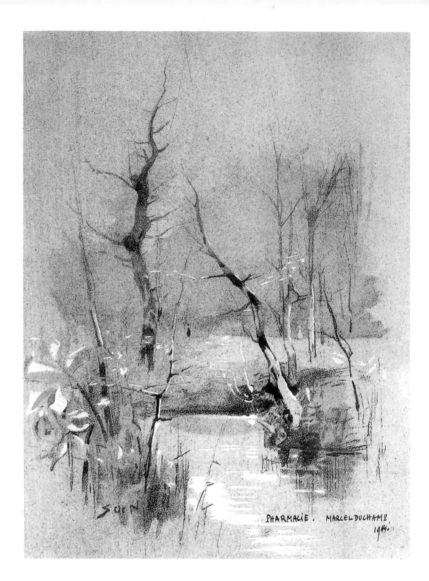

Pharmacy, 1914
Pharmacie
Readymade: gouache on an art print,
26.2 x 19.3 cm
Milan, Collection Arturo Schwarz

his works – boxes containing exact replicas of his messy jottings and sketches – consist of the atmosphere or fabric of ideas woven between written comments. (The first box of replicated notes was published in an edition of four or five as early as 1914.) Later on in his life he would replicate many of his important works in doll's house format and pack them up into fold-out boxes so that they could be handled and considered in close contact to one another. This is a radical change from the idea of a work of art that ends with its completion.

In 1913–14, Duchamp made a strange object that was to remain one of his favorite works and mark his break with art as it was known to that day: the *3 stoppages étalon* or *3 Standard Stoppages* (pp. 46/47). It wasn't a sculpture and it wasn't a painting. It was a box containing an idea, one application of that idea, and the "law" that resulted from it. Duchamp conducted an experiment using three pieces of ordinary thread that were one meter long. From a height of one meter, he let the threads fall onto

painted canvas surfaces, where they landed three successive times in three random, undulating positions that are as graceful as the outline of a Matisse nude. Duchamp glued them with varnish onto a painted bluish-black monochrome canvas surface. The canvas strips were affixed to glass plates and wooden slats were cut along one edge to echo the curve of the strings. The glass plates and the wooden slats were fitted into a croquet box. The title was printed in gold letters on three small leather signs glued onto the dark stoppage backgrounds. Years later, two straight wooden sticks marked with their length were added at Duchamp's suggestion when the piece was shown in 1953 at the Museum of Modern Art in New York. Duchamp appears to be following Poincaré quite literally, who presented a "School of the Thread" in four pages of a chapter on classical mechanics.[29]

The *3 Standard Stoppages* became tools by which to measure and create other lines, much like the boxed platinum standard meter kept at the International Office for Measures and Weights in Sèvres. One might also think of Roussel's "Etalon à platine". Obviously, Duchamp's units of measurement set new, humorously variable and arbitrary standards, but standards they were. He immediately used them to determine distances and locations on other works, such as the *Network of Stoppages* (1914, p. 48). And the *Network of Stoppages*, in turn, refers directly to the future *Large Glass* (pp. 74/75). As if this were not complicated enough, the *Network* also incorporates an unfinished image of the past, namely a larger version of *Young Man and Girl in Spring* from 1911 (p. 18), which Duchamp had given to his sister Suzanne as a wedding gift and which was influenced by Matisse.

During 1913, Duchamp had begun working on his first actual plans for *The Large Glass*, some of which he made while chaperoning his married sister Suzanne on a trip to Herne Bay, England. They are faint sketches full of numbers and lines that recall mechanical drawing and architectural plans. His studies of historical treatises on perspective, as well as of modern geometry and dimension at the Bibliothèque Sainte-Geneviève, helped him determine the proportions and appearance of the work, which he would labor on intermittently for the next decade. Perhaps at first because he had no other canvas at hand, Duchamp took the older unfinished work and used it as a background for his *Network of Stoppages*. However, instead of repainting it entirely, he diminished only the rims of the original composition to reduce it to the half-scale proportions of the planned glass. A layout of *The Large Glass* was penciled in over the painting.

Then Duchamp tipped the canvas on its side. With the aid of the stoppage slats, he drew lines that began on the lower right corner of the canvas and branched out and up to the left. They cover what may be considered the "male" parts of the canvas: the zone of the uncompleted young male figure from *Spring*, as well as the bachelor realm of the future *Large Glass*. Under her arbor, the female figure of *Spring* is positioned in the zone of the coming bride. Here, in this old vision of paradise, the male and the female areas of the glass are not entirely separated. On *The Large Glass* itself, the stoppages will be limited to the lower half, the realm of the bachelors. The circles and numbers on the stoppages mark the locations of what Duchamp termed in his notes the "nine malic molds" (cf. p. 36), while the lines themselves have become nine "capillary tubes".

Another image from 1913, the *Chocolate Grinder*, was an oil study for

Young Man Standing, 1909–10
Chinese ink on paper, 43 x 28 cm
Dinard, Collection Mme Babette Babou

PAGE 46/47:
3 Standard Stoppages, 1913–14
3 stoppages étalon
Assemblage: in a croquet box (129.2 x 28.2 x 22.7 cm) are three threads at least 1 meter long, glued to strips of canvas (120 x 13.3 cm), each mounted on glass (125.4 x 18.4 cm). The plates of glass are each assigned to a wooden slat, shaped to match the curves of the threads.
New York, The Museum of Modern Art, Katherine S. Dreier Bequest

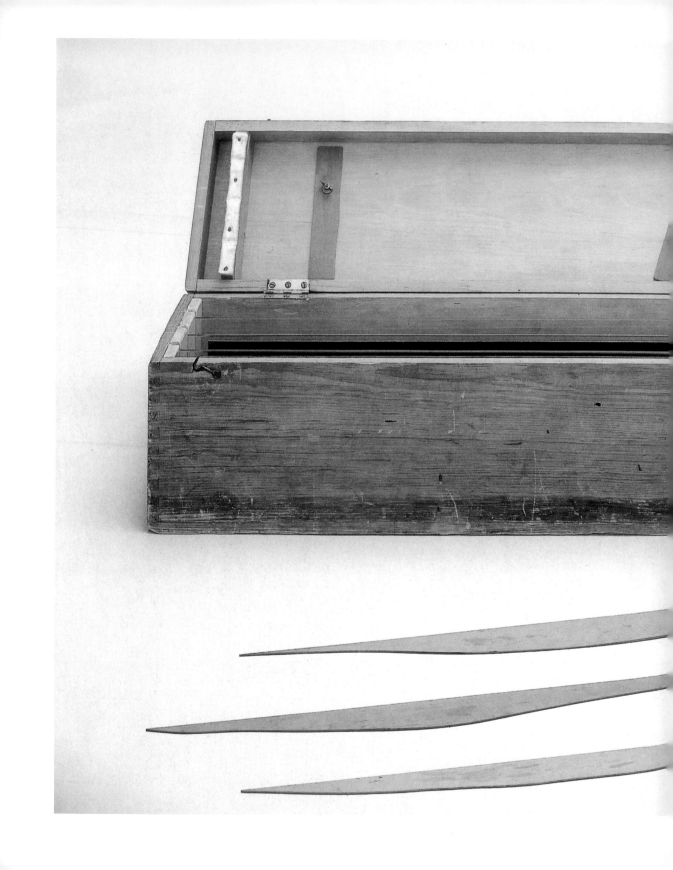

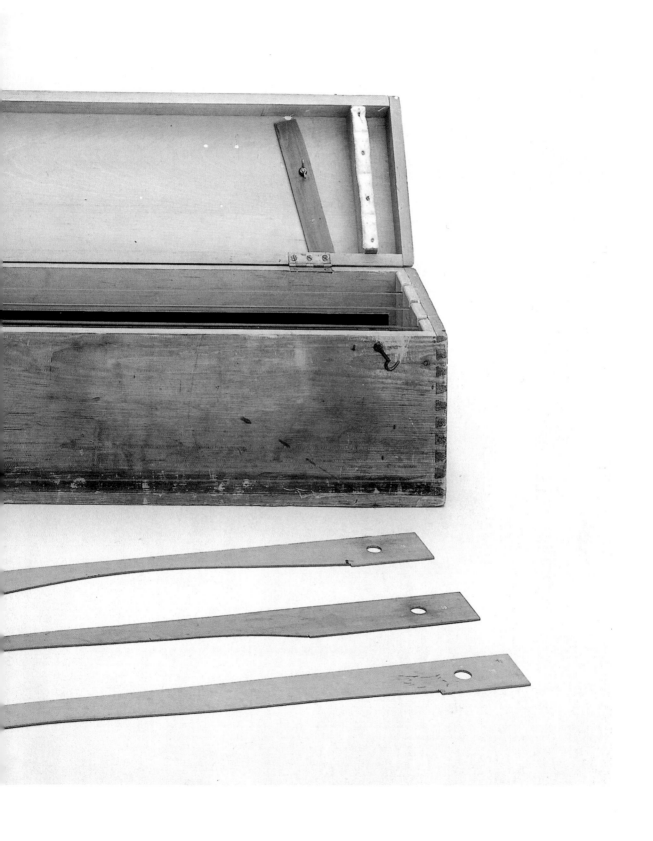

another of the principal elements of the bachelor realm. Duchamp had seen a chocolate grinder at work in the window of a sweet shop in Rouen, and adapted it for his own purposes by placing it on a short table with curving legs. The sensual connotations of chocolate accompany the mechanical image, which became for Duchamp a metaphor for masturbation. A second oil painting of the grinder (*Chocolate Grinder No. 2*, p. 38) included threads sewn into the canvas in an exact perspectival execution (1914). The threads radiate out from the centers of the grinding drum surfaces like the spokes of a bicycle wheel. Duchamp was trying to eliminate all painterly qualities from his production. "Through the introduction of straight perspective and a very geometrical design of a definite grinding machine like this one, I felt definitely out of the Cubist straightjacket. The general effect is like an architectural, dry rendering of the chocolate grinding machine purified of all past influences. It was to be placed in the center of a large composition and was to be copied and transferred from this canvas onto *The Large Glass*."[30] There were also other, similarly "dry" studies carried out with the material of glass itself, such as the *Glider Containing a Water Mill in Neighboring Metals* (1913–15, p. 35), whose imagery is pressed between two semicircular panes of glass and whose metal frame is mounted on a movable hinge that swings it out away from the wall. The *Glider* is a surprisingly aesthetic work – beautiful in its austerity and amazingly modern in its inclusion of technological forms.

While Duchamp was inventing the repertoire of forms for this major work – the machinery and parts of the bachelors and the bride – he did two strange things. He mounted a bicycle wheel on a stool, and kept it in his studio, spinning it occasionally with his hand, just to watch it. He denied any reason for this, simply saying, "I enjoyed looking at it, just as I enjoy looking at the flames dancing in a fireplace."[31] Molderings has recognized in it the type of device physicists use to demonstrate the effect of angular momentum or prove the effect of centrifugal forces on a free axis.[32] This *Bicycle Wheel* (p. 50) certainly bears a relationship to Du-

Network of Stoppages, 1914
Réseaux des stoppages étalon
Oil and pencil on canvas, 148.9 x 197.7 cm
New York, The Museum of Modern Art,
Gift of Mrs. William Sisler and Edward James
Foundation, 1970

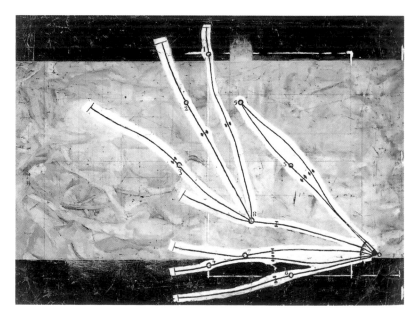

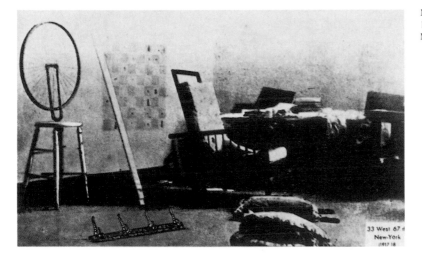

Marcel Duchamp's atelier during the period 1917–18, West 67th Street, New York
Milan, Collection Arturo Schwarz

champ's rotating *Coffee Mill* (p. 25) and *Chocolate Grinder*, and also to the circle of dancers in *Young Man and Girl in Spring* (p. 18). In addition, however, its shape is roughly anthropomorphic; indeed, it resembles a strange portrait Duchamp painted in 1911 of Gustave Candel's mother, where an inert pedestal is combined with an animate head. It even seems akin to a wheel-headed bachelor in his drawing for the *Cemetery of Uniforms and Liveries (No. 1)* (1913, p. 36). The phonetic collage of *roue* (wheel) and *sellette* (stool) could make it a "little" portrait of Roussel. In his notes, Duchamp refers to the bride several times as "the arbor-type". Although this term also refers to trees, in both French and English it has secondary meanings that associate it with a wheel mounted on a shaft, which would connect the *Bicycle Wheel* directly to *The Large Glass* (pp. 74/75). The second strange thing Duchamp did was to purchase a household bottle rack from a department store, which he also placed in his studio with no intention of using it to dry bottles. As indifferent and autonomous as its mass-produced shape appears, it has a presence both skirted and phallic. These two objects kept Duchamp company while he worked in his attic studio in Paris.

In the meantime, the painting rejected by the Cubists in 1912, *Nude Descending a Staircase (No. 2)*, was making Duchamp the most famous modern artist in the United States. It had been selected for the Armory Show, held in the 69th Regiment Armory building in New York, which included about 1,500 works by American and European artists. The international section got the most attention. Its viewers were surprised and bewildered at the modern works that violated their sense of art. The most scandalous painting was Duchamp's *Nude*. Because the enraged public could not recognize the nude, it was likened to many things they thought they might have recognized, such as an explosion in a brick factory or a pile of old golf clubs. Critics made fun of the exhibition and encouraged the public to attend it as if it were a circus. The international section of the exhibition was so controversial that it traveled on to two other places, Chicago and Boston.

Although the general public was not capable of understanding the new work, an elite group of wealthy, culturally interested Americans were hungry for the European break with academic and traditional art. The independently wealthy Picabia, who was able to afford to travel to the Ar-

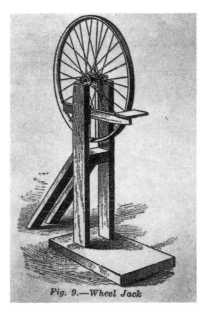

Fig. 9.—Wheel Jack

Drawing of a wheel jack, c. 1912

If one compares the wheel jack with Duchamp's assemblage, the *Bicycle Wheel*, the similarity between the two is immediately apparent.

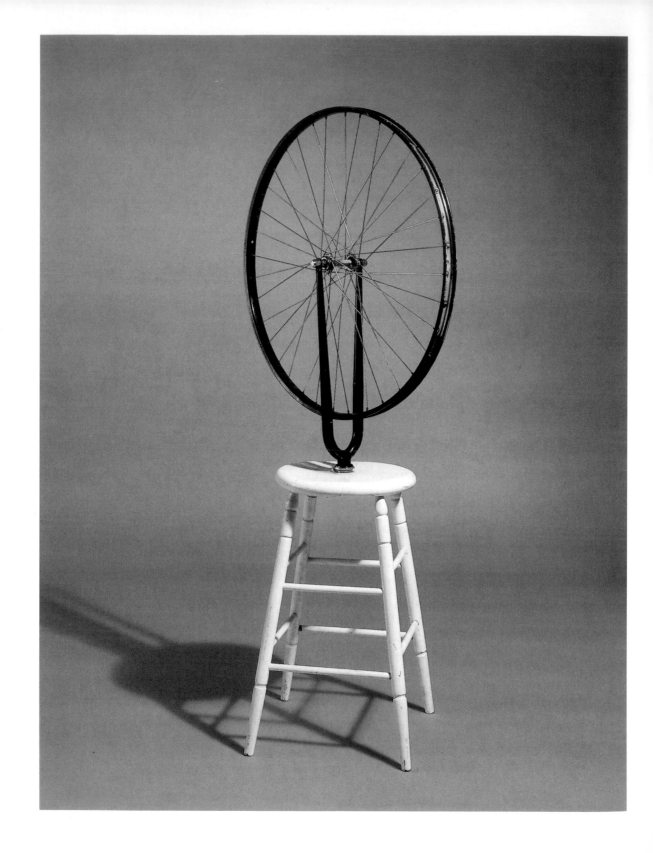

mory Show, was delighted by the sale of 300 of his paintings as well as by the welcome he received. Duchamp, too, sold all four of his exhibited paintings, which gave him enough money to finance a trip to the United States in 1915. After the World War I was declared in 1914, Paris became an unpleasant place for Duchamp, who was neither nationalistic nor political. His brothers and many of his friends, including Apollinaire, were in the army. Duchamp, who was exempted from the military for health reasons, decided to emigrate to the still neutral United States.

When Duchamp arrived in New York, he was surprised to find that he was a famous man. Immediately after his arrival, he met Walter and Louise Arensberg, who became his main patrons and collectors. Duchamp actually lived with them for several weeks, and after two moves, he took an apartment in the same house as the Arensbergs and lived there for almost two years. Duchamp's payment for the rent was to be *The Large Glass* (pp. 74/75), ownership of which was eventually transferred to the Arensbergs. This was the beginning of a forty-year friendship, during which Duchamp helped Walter Arensberg build up a representative collection of modern art, including all of the numerous Duchamp works that are in the Philadelphia Museum of Art today.

Gabrielle Buffet-Picabia describes the Arensbergs as "generous and intelligent patrons of the arts, where at any hour of the night one was sure of finding sandwiches, first-class chess players, and an atmosphere free from conventional prejudice. The Arensbergs showed a sympathetic curiosity, not entirely free from alarm, towards the most extreme ideas and towards works that outraged every accepted notion of art in general and of painting in particular." She continues, "We had found Marcel Duchamp perfectly adapted to the violent rhythm of New York. He was the hero of the artists and intellectuals, and of the young ladies who frequented these circles. Leaving his almost monastic isolation, he flung himself into orgies of drunkenness and every other excess... In art he

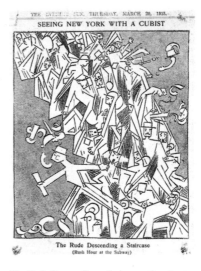

The Rude Descending a Staircase, a contemporary cartoon on the Armory Show by J.F. Briswold, from *The New York Evening Sun*, 20 March 1913

New York, The Museum of Modern Art
The Armory Show was the American public's first confrontation with modern European developments in art that led painting away from showing recognizable objects. Duchamp's contribution, *Nude Descending a Staircase, (No. 2)*, was widely attacked and caricatured.

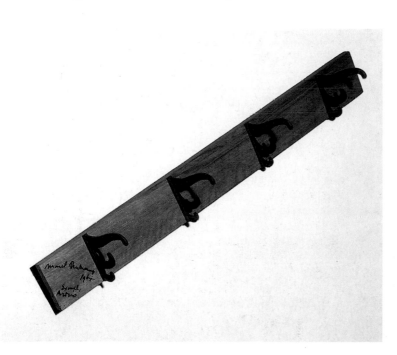

Trap, 1917
Trébuchet
Readymade: coat-rack plank made of wood, fixed to the floor, 11.7 x 100 cm, original lost
New York, The Mary Sisler Collection, Courtesy Fourcade, Droll, Inc.

PAGE 50:
Bicycle Wheel, 1913
Roue de bicyclette
Readymade: bicycle wheel, diameter 64.8 cm, mounted on a stool, 60.2 cm high, original lost
Milan, Collection Arturo Schwarz

51

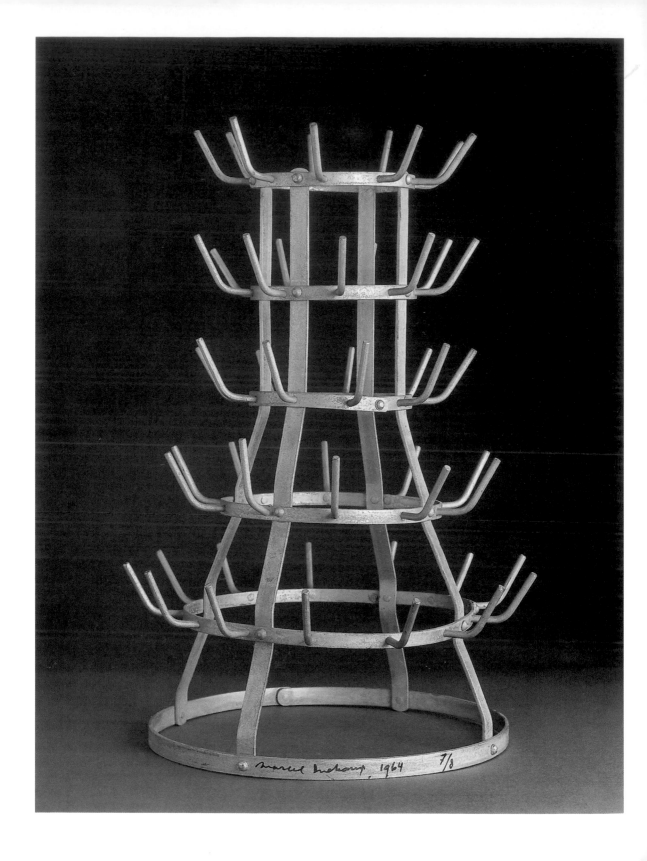

The first exhibition of the *Bottle Rack* in the Exposition Surréaliste d'Objets, Charles Ratton Gallery, Paris 1936

From the catalogue of the *Bazar de l'Hôtel de Ville*, Paris 1912. Of the various types of bottle racks available, Duchamp selected the 50-bottle model.

PAGE 52:
Bottle Rack, 1914/1964
Egouttoir (or Porte-bouteilles or Hérisson)
Readymade: bottle rack made of galvanized
iron, original lost, 59 x 37 cm
Collection Diana Vierny

Man Ray
Self-Portrait, 1924
Black and white photograph
Paris, Musée National d'Art Moderne,
Centre Georges Pompidou

From the biography of Man Ray: "Duchamp
had asked me to come to the apartment of the
proposed founder of the new museum, to dis-
cuss the project. When I arrived I was ushered
by a maid into a room lined with books and
modern paintings, mostly Expressionists. Here
and there stood a piece of sculpture on a ped-
estal. Presently, Duchamp arrived; shortly
after, the hostess entered: Katherine S. Dreier.
She was a large, blond woman with an air of
authority. I was introduced and she announced
that tea would be served. I fingered my pipe
in my pocket, but decided not to smoke. The
place was gleaming, immaculate, with no sign
of an ashtray.
Miss Dreier opened the session by declaring
that first a name had to be given to the new
venture. After a few suggestions, I had an idea
– I had come across a phrase in a French
magazine that had intrigued me: *Société An-
onyme* – which I thought meant Anonymous
Society. Duchamp laughed and explained that
it was an expression used in connection with
certain large firms of limited responsibility –
the equivalent of *incorporated*. He further
added that he thought it was perfect as a name
for a modern museum."

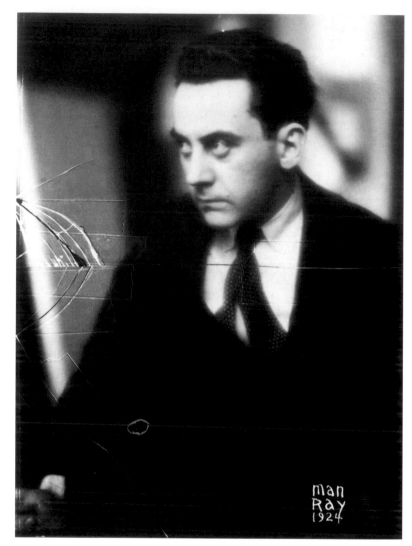

was interested in finding new formulas with which to assault the tradition
of the picture and of painting; despite the pitiless pessimism of his mind,
he was personally delightful with his ironies. The attitude of abdicating
everything, even himself, which he charmingly displayed between two
drinks, his elaborate puns, his contempt for all values, even the sentimen-
tal, were not the least reason for the curiosity he aroused, and the attrac-
tion he exerted on men and women alike."[33]

The writer Henri Roché described being at a dance with Duchamp:
"I was expecting a rather lonely evening, but couples started arriving,
young women disengaged themselves and sat down on the floor around
Marcel Duchamp; soon it was a dozen, who were quickly followed by
some of their partners. Duchamp asked two ladies to take care of me, and
soon I heard the following: three years ago, he had painted a painting for
the Armory Show entitled *Nude Descending a Staircase*. This picture was
considered by one half of America to be a work of the devil, while the

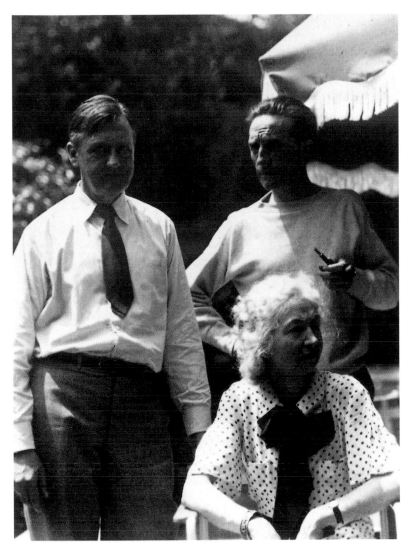

Marcel Duchamp with Louise and Walter
Arensberg in Hollywood, 1936
Philadelphia (PA), Philadelphia Museum of
Art: Collection Louise and Walter Arensberg

other half thought it a pioneering masterpiece. At this time, Marcel Du-
champ was the most famous Frenchman in New York, next to Napoleon
and Sarah Bernhardt."[34]

Duchamp was a success. However, nothing could tempt him to paint
any further, since he was already planning his *Large Glass* (pp. 74/75).
Not even when a gallery offered 10,000 dollars a year for his entire pro-
duction would he do so. Duchamp might have felt his work was in
danger of being sensationalized. It is interesting to note that around the
same time P.T. Barnum also offered Sarah Bernhardt the exact same
amount of money for her diseased leg, should it be amputated, since he
wanted to exhibit it.[35]

Despite his initial fame, Duchamp soon disappeared into the closed fam-
ily of the intellectual avant-garde. Among the American artists Duchamp
quickly got to know was Man Ray, who often photographed him and his
work, and who collaborated with him on several projects. He would re-

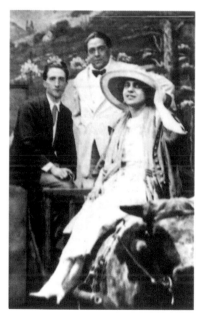

Marcel Duchamp, Beatrice Wood and Francis
Picabia in Coney Island, New York, 1917
Milan, Collection Arturo Schwarz

main Duchamp's friend all of his life, and Man Ray's autobiography re-
veals that Duchamp's ideas influenced and guided him to a great extent.
A little later, Duchamp also met Katherine Dreier, who became his other
main patron, and with whom he and Man Ray founded the Société An-
onyme, an organization for collecting and exhibiting modern art. Although
Duchamp gave some French lessons and dealt in art on a commission
basis, it was his wealthy patrons who kept him afloat in New York.

Despite his being a much sought-after guest, Duchamp settled down to
work on his *Large Glass*, a task that would be undertaken intermittently
until 1923, when the work was declared officially unfinished. In 1915, he
bought the rectangular plate-glass, laid it down horizontally on wooden
supports and began to mark the silhouettes of the mechanistic shapes
and objects he had designed for the piece. The figure of the bride came
first. Duchamp defined the contours with lead wire, which was affixed
with varnish to the glass the wrong way around; he worked only on the
reverse surface of the glass, which was meant to be viewed eventually
from the untouched smooth side. One of the ideas behind working on
glass was its hygienic aspect, since the glass was to protect the images
from changes brought about by air contact. In this context it is also inter-
esting to note that Duchamp had a bathtub in the middle of his studio for
a while, from which he could open his door through a system of pulleys,
just in case he needed to admit a guest during his bath. (A similar idea
had already been used by Buster Keaton in one of his films.)

It was only after he had spent some time working on the glass in New
York that Duchamp began to readjust his ideas about the *Bicycle Wheel*
and the *Bottle Rack* he had left back in Paris. In a letter to his sister Su-
zanne dated 15 January, 1916, Duchamp requested her to move his things
out of his studio in Paris. She was to take care of his belongings, and
store his art. Duchamp wanted Suzanne to write something on the *Bottle
Rack*, and he explained to her why:

"Now, when you went upstairs, you saw the bicycle wheel and a bottle

rack in my studio. I bought that as an already finished sculpture. And I have an idea about the bottle rack: listen.

Here in New York I have bought some objects of a similar style and called them 'readymade', you know enough English to understand the meaning of 'already finished' that I have assigned to these objects – I sign them and put an inscription on them in English. I'll give you a few examples: I bought a big snow shovel upon which I wrote 'In advance of the broken arm' ... Don't try too hard to understand this in a romantic or impressionistic or cubistic way – it doesn't have anything to do with that; another 'readymade' is called 'Emergency in favor of twice' ... This whole preamble is for one reason: Go get the bottle rack. I am making it into a readymade from afar. On the inside of the bottom ring you will write the inscription I will give you at the end here, using small letters and painting them on with a brush and silver-white paint, and in the same lettering you are to sign it as follows: Marcel Duchamp."[36]

Unfortunately, the page of the letter with the details of the inscription is lost, and decades later Duchamp said he could no longer remember what it was. Also, there is no way of knowing if Suzanne Duchamp actually inscribed it before both the bottle rack and the bicycle wheel/stool assemblage got thrown away in the cleaning out of Duchamp's deserted Paris studio. Although the *Bottle Rack* (p. 52) is now dated to 1914, the year in which Duchamp purchased it in a Parisian department store, and his *Bicycle Wheel* assemblage (p. 50) to 1913, conceptually these two objects only became readymades in 1916 while he was working on *The Large Glass*.

The first Readymade to be called such was the snow shovel from 1916 referred to in the letter above (p. 58). It hung down from the ceiling in Duchamp's messy studio. The title, *In Advance of the Broken Arm*, remains puzzling, suggesting something disabling and mysterious. The hanging shovel shares the verticality of the *Bicycle Wheel* and the *Bottle Rack*, but –

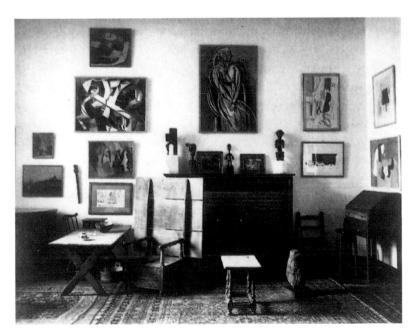

The apartment of Louise and Walter Arensberg in New York, c. 1918
Photograph by Charles Sheeler
Philadelphia (PA), Philadelphia Museum of Art: Collection Louise and Walter Arensberg

The Arensbergs tried to assemble as complete a collection of Duchamp's art as possible. Today, their collection forms the core of the Duchamp works in the Philadelphia Museum of Art.

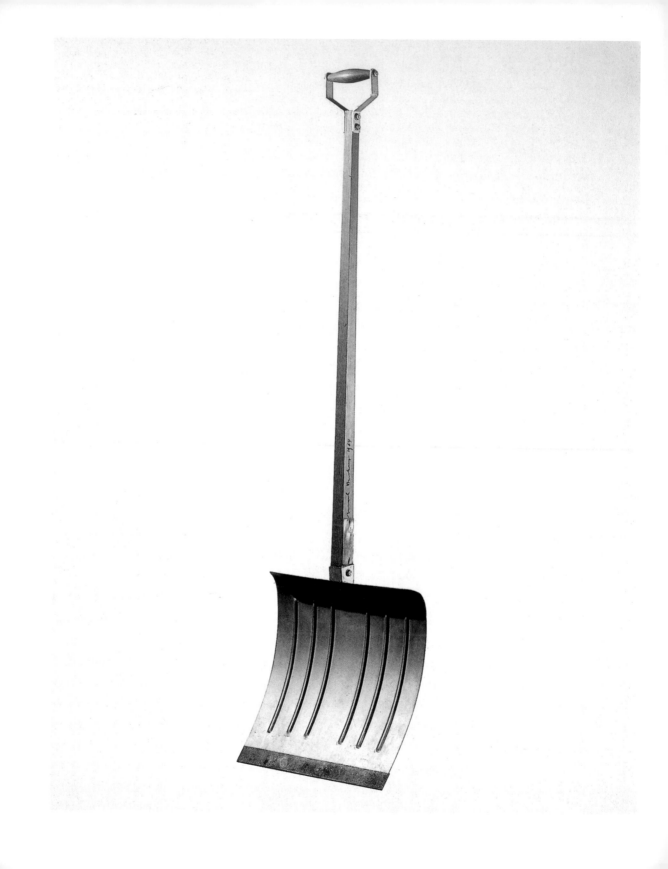

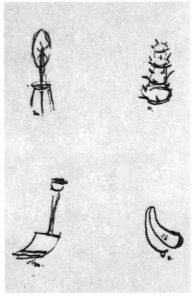

Sculpture for Traveling, 1918
Variable sculpture, colored rubber and string,
dimensions ad lib, original destroyed
Copy by Richard Hamilton on the occasion of
the Duchamp retrospective in the Tate Gallery
(London) in 1966
Milan, Collection Arturo Schwarz

Four Readymades, 1964
Lithograph, 32 x 23.2 cm
Milan, Collection Arturo Schwarz

In Advance of the Broken Arm, 1915
Readymade: snow shovel, wood and gal-
vanized iron, 121.3 cm
New Haven (CT), Yale University Art Gallery,
Gift of Katherine S. Dreier for the Collection
of Société Anonyme, 1946

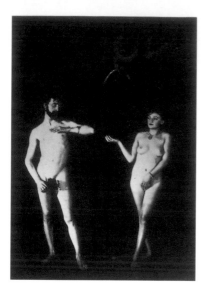

Man Ray
Cine-sketch: Adam and Eve (Marcel Du-
champ and Brogna Perlmutter-Clair), 1924
Photograph, 11.5 x 8.6 cm
New York, Collection Michael Senft

PAGE 61:
Sex Cylinder (Wasp), 1934
Pencil on paper, 31 x 27 cm
Milan, Collection Arturo Schwarz

when considered in the context of *The Large Glass* (pp. 74/75) – also
refers to the bride. As the drawing *The Female Hanged Body* shows, one
early version of the bride actually has a shovel at its center. The note ac-
companying this figure says, "At A, terminating the pole a kind of mortice
(look for the exact term), held by a bowl and permitting movement in all
directions of the pole agitated by the air currents." (Among the replicate
notes in what is known as the *Green Box*.) Duchamp
changed this idea into the movement of the bride's veil. The shovel be-
comes three wafting surfaces and refers to what Duchamp called "draft pis-
tons" or "nets", which also have small shafts from which they dangle. Simi-
larly, the *Bottle Rack* – tipped onto its crown of thorns – seems to reappear
in another sketch for the bride, serving as a model for the *Sex Cylinder
(Wasp)* (p. 61). Martin Kunz has recognized other readymade aspects of
The Large Glass, for example, the material of glass itself as an already
completed background, and the yellowish dust coloring the "sieves"
in the realm of the bachelors.[37]

Duchamp's readymades have usually been considered apart from his
Large Glass, since they came into being spontaneously as individual ob-
jects, while *The Large Glass* was the culmination of the labor of many
years. However, the early readymades seem to have been chosen for their
abilities to serve as prototypes for elements of *The Large Glass*, or, think-
ing in the other direction, to transpose the ideas for *The Large Glass* into
the three-dimensional space of Duchamp's studio. (This idea makes the
paintings of the chocolate grinder seem like paintings of a readymade
Duchamp couldn't buy.) It is interesting that Duchamp did exhibit a
few of the early readymades in 1916 by simply hanging them up on the
coatrack of the gallery in question, which brought them into the associa-
tive sphere of clothing and bodies, as well as the hanging bride. There is
some evidence that the first readymades constituted a spatial ensemble.
Photographs of Duchamp's studio/living space show some of the ready-
mades suspended from his ceiling, nailed to the floor or set up in a cor-
ner. One of them, the *Sculpture for Traveling* (p. 59), was a collapsible
sculpture made from colored strips of cut-up bathing caps. It stretched
through the space in abstract lines of movement, reminiscent of Du-
champ's self-portrait as a *Sad Young Man in a Train* (p. 24), whom he
described as being almost "elastic". Such visual affinities suggest that
The Large Glass was meant to reflect an entirely emotionless dimension
of a highly personal realm.

(guêpe).

Ventilation : ~~Première~~ Partie d'un courant d'air
intérieur -

Major Accomplishments

The readymades – Duchamp's elimination of the individual, handmade quality of art – changed in character, asserting their own qualities apart from *The Large Glass*, though not from Duchamp himself. They almost always have an autobiographical reference, however, their element of humor is even stronger. *With Hidden Noise* (1916, p.64) is a ball of twine screwed between two brass plates. Inside the twine, Walter Arensberg placed an object unknown to Duchamp, while on the brass plates, Duchamp inscribed two phrases whose meaning was hidden from Arensberg by the deletion of letters. It rattles, but is secretive. *Traveler's Folding Item* (1916, p.67) was the flexible black cover of an Underwood typewriter – a handy work of art for taking on trips, as well as a teasing, skirt-like reference to a girlfriend of Duchamp's at the time, Beatrice Wood, whom he also enjoyed teaching rude words in French.

The *Unhappy Readymade* (1919, p.63) was to be executed by his sister Suzanne on the occasion of her second marriage to the painter Jean Crotti: she was to hang a geometry book out on her balcony so that the wind could turn the pages and pick out the problems for the weather to destroy. It eventually dissolved and was documented in a painting by Suzanne. Made as a gift for Walter Arensberg, *50 cc of Paris Air* (1919, p.67) was a glass ampoule of medicine that was broken, emptied and mended by a druggist in Paris, so that it contained Paris air. A postcard of the Mona Lisa was penciled with a mustache and a goatee and awarded the caption *L.H.O.O.Q.* (1919, p.65), which in French reads phonetically "Elle a chaud au cul" (She's got a hot ass). But the most amusing and the most destructive readymade of all was *Fountain* (1917, p.66).

In 1917, a new Society for Independent Artists was founded in New York, modeled after the Paris Salon des Indépendants. Anyone who paid six dollars was allowed to submit two works. Duchamp was one of the directors of the group, but he didn't like the organization and decided to goad those responsible for hanging and placing the art objects. He submitted *Fountain* under a pseudonym.

Fountain was a urinal, the kind of urinal that, when installed in a public bathroom, can only be used by standing urinating men. Without a doubt, it was a mirage of standing urinating men and other spicy possibilities that arose before the eyes of the society's hanging committee when confronted by it. Duchamp had bought the urinal and simply placed it on its flat side so that it would stand "erect". He signed the base, right next to the hole for the plumbing: R. Mutt. Although the signature was inspired by the comic-strip characters Mutt and Jeff, and the "R." stood for "Richard", French slang for "moneybags", the hanging committee prob-

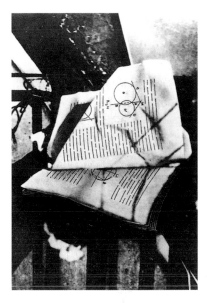

Unhappy Readymade, 1919
Readymade malheureux
Readymade: geometry textbook. Original destroyed, dimensions unknown
Black and white photograph

PAGE 62:
Marcel Duchamp at an exhibition of his work in Pasadena Art Museum, Los Angeles, 1963
Photograph by Julian Wasser

With Hidden Noise, 1916
A bruit secret
Assisted readymade: ball of string between
two brass plates held together by four screws.
12.9 x 13 x 11.4 cm
If the readymade is moved, it makes a noise.
Philadelphia (PA), Philadelphia Museum of Art:
Collection Louise and Walter Arensberg

PAGE 65:
Reproduction of ***L.H.O.O.Q.***, 1919
from ***Box in a Valise***
(Boîte-en-valise)
Assisted readymade: pencil on a reproduction
of the Mona Lisa, 19.7 x 12.4 cm
Philadelphia (PA), Philadelphia Museum of Art:
Collection Louise and Walter Arensberg

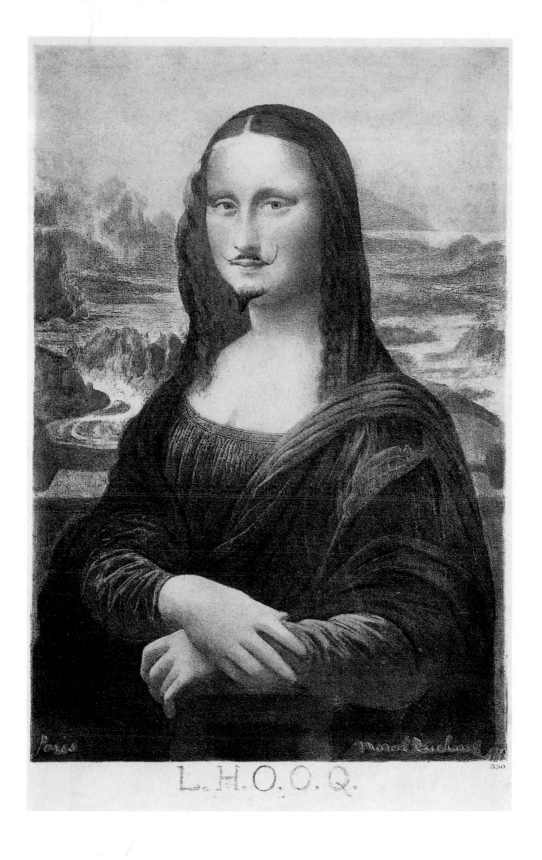

L. H. O. O. Q.

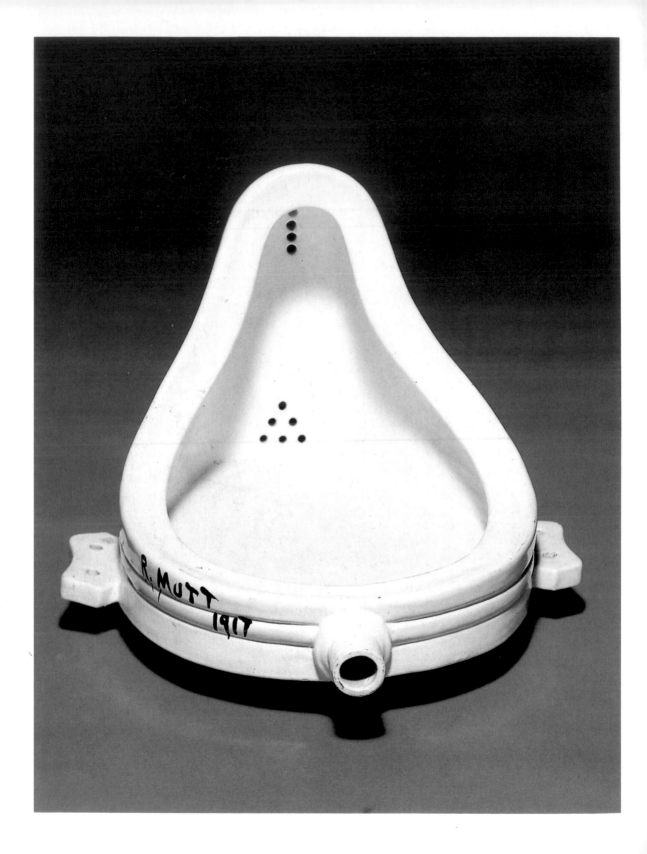

Traveler's Folding Item, 1916
Readymade: typewriter dust-cover, by the
Underwood company, height 23 cm
New York, The Mary Sisler Collection
Courtesy Fourcade, Droll, Inc.

50 cc of Paris Air, 1919
Air de Paris
Readymade: glass ampoule, diameter
6.35 cm, height 13.3 cm
Philadelphia (PA), Philadelphia Museum of
Art: Collection Louise and Walter Arensberg

ably thought first of a filthy cur. But Duchamp was also playing on the
real name of the company he bought it from, the "Mott Works" in New
York, which he changed slightly, in the manner typical of him.

Fountain never made it into the exhibition (the first problem would
have been the embarrassing question of the height of its placement), al-
though R. Mutt had paid his six dollars to show. It was also not mentioned
in the catalogue. Strangely enough, Katherine Dreier, who was familiar
with Duchamp's other readymades and a member of the hanging commit-
tee, didn't recognize his gesture behind the pseudonym.[38] Complaints were
made. Walter Arensberg was in on the prank, and offered to buy *Fountain*
to support the artist, but it couldn't be found. After a while the urinal was
discovered behind a partition wall, where it had waited out the entire dura-
tion of the exhibition. Alfred Stieglitz was persuaded to take an almost en-
nobling photograph of *Fountain*, which appeared in the second issue of
The Blind Man, a magazine published by Duchamp, Beatrice Wood and
H.-P. Roché. There, R. Mutt's case was defended with feigned innocence:
"Now Mr. Mutt's *Fountain* is not immoral, that is absurd, no more than a
bathtub is immoral. It is a fixture that you see every day in plumbers'
show windows. Whether Mr. Mutt with his own hands made the *Fountain*
or not has no importance. He CHOSE it. He took an ordinary article of
life, placed it so that its useful significance disappeared under the new title
and point of view – created a new thought for that object."[39]

Strangely enough after all this, the original urinal was finally mis-
placed by Arensberg himself. Just like the *Bicycle Wheel* (p. 50), the
Bottle Rack (p. 52), *In Advance of the Broken Arm* (p. 58) and other
readymades, it has since been replaced by replicas. The thought, not the
object, was saved.

Around 1920, the readymades became more complicated. Instead of
buying manufactured objects to inscribe and sign, Duchamp made (or
had someone make) several constructions or assemblages. *Fresh Widow*
(p. 69) was a small model of what Americans call a French window. A
carpenter built it for Duchamp. It has cheery green casing and black
leather panes. The pun is obvious. A similar window was *The Brawl at*

PAGE 66:
Fountain, 1917/1964
Fontaine
Readymade: porcelain urinal, 23.5 x 18 cm,
height 60 cm
Milan, Collection Arturo Schwarz

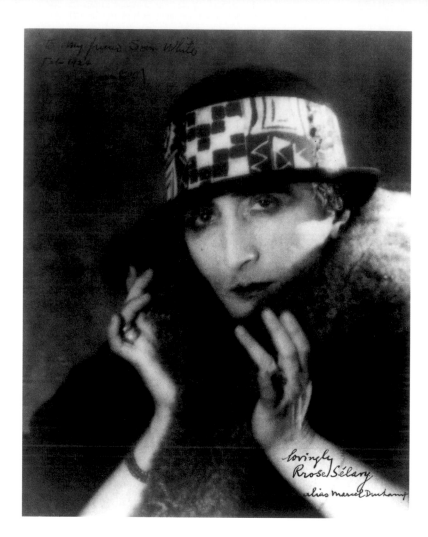

Austerlitz (1921, p. 68), whose panes still carry the glazier's marks – the readymade initials of Suzanne Crotti, Duchamp's sister, with whom he was staying in Paris at the time of its production.

Fresh Widow – a puzzle of seeing and not seeing, of female closed openness, of sprightly death – was the first work Duchamp signed with the name of his female alter ego, Rose Sélavy, whom he invented in New York in 1920. In a way, Rose Sélavy became a work of art, although not the pretty girl a transvestite might have tried to create. Duchamp dressed up as a woman for a photograph by Man Ray of "Rose" (p. 70); this forage into femaleness does not focus on the body, but rather on the inscrutable expression of Duchamp's hands and face. A calling card was printed for Rose that read:
"PRECISION OCULISM
ROSE SÉLAVY
New York/Paris
COMPLETE LINE OF
WHISKERS AND KICKS"

WANTED

$2,000 REWARD

For information leading to the arrest of George W. Welch, alias Bull, alias Pickens, etcetry, etcetry. Operated Bucket Shop in New York under name HOOKE, LYON and CINQUER. Height about 5 feet 9 inches. Weight about 180 pounds. Complexion medium, eyes same. Known also under name RROSE SÉLAVY

Wanted, $2,000 Reward, 1923
Rectified readymade: photocollage on poster,
49.5 x 35.5 cm
Milan, Collection Arturo Schwarz

Poster for the Retrospective at the Pasadena Art Museum, 1963. It inspired Andy Warhol's series *Most Wanted Men*.

There had always been androgynous flashes in Duchamp's work. The very first might be the drawing of Leo Tribout, the wife of one of Duchamp's oldest friends, shown as a young man (1909–10; p. 45 above), followed by the young couple of *Young Man and Girl in Spring* (p. 18), the nude on the staircase (p. 26), even the *Bottle Rack* (p. 52), with its curves and jutting parts, and certainly the be-whiskered Mona Lisa (p. 65). The choice of the name "Rose" could even be an indirect reference to the poetic circle of roses invented by the famous Jewish lesbian, Gertrude Stein. At any rate, Rose/Eros Sélavy became a communicative personification of this androgynous tendency. In an interview with Pierre Cabanne, Duchamp commented:

"I wanted to change my identity and first I had the idea of taking on a Jewish name. I was Catholic and this switch of religion already meant a change. But I didn't find any Jewish name that I liked or that caught my fancy, and suddenly I had the idea: why not change my sex? That was much easier!

And that's where the name Rrose Sélavy comes from. Today that

Vous pour moi, 1922
Printed suitcase labels for Rrose Sélavy,
6 x 12 cm
New Haven (CT), Beinecke Rare Book and Manuscript Library, Yale University Library

sounds pretty good, because even names change with time, but then Rose was a stupid name. The double "R" has to do with Picabia's picture *Œil Cacodylate*, which was hanging in the bar 'Le Bœuf sur le Toit'... that Picabia wanted all of his friends to sign. I think I wrote 'Pi qu'habilla Rrose Sélavy' [phonetically 'Picabia l'arrose c'est la vie']."[40]

The play on words "Eros c'est la vie" (Eros that's life) or "arroser la vie" (drink it up, celebrate life) indicates a viewpoint that underlies Duchamp's works. Because *The Large Glass* and his readymades do not look overtly sexual or erotic, it is surprising to be referred back to this allencompassing interest. However, Rose or Rrose Sélavy did not only make works of art, she also wrote bon mots, spoonerisms and puns that were occasionally published, and they are often quite explicit. Michel Sanouillet and Elmer Peterson have dedicated a whole chapter to them in their book, *Salt Seller – The Writings of Marcel Duchamp*.[41] Examples:

"Rrose Sélavy trouve qu'un incesticide doit coucher avec sa mère avant de la tuer; les punaises sont de rigueur."
("Rrose Sélavy finds that an incesticide must sleep with his mother before killing her; bed bugs are de rigueur.")
"Question d'hygiène intime:
Faut-il mettre la moelle de l'épée dans le poil de l'aimée?"
("Question of intimate hygiene:
Should you put the hilt of the foil in the quilt of the goil?")
"Abominables fourrures abdominales."
("Abominable abdominal furs.")
or the English, "My niece is cold because my knees are cold."

The sexuality of Rrose Sélavy brings us finally to a consideration of the two major works by Marcel Duchamp, *The Bride Stripped Bare By Her Bachelors, Even* (1915–23, pp. 74/75) and *Etant donnés: 1° la chute d'eau, 2° le gaz d'éclairage* (*Given: 1. The Waterfall, 2. The Illuminating Gas*; 1946–66, pp. 85–89). Both of these works with long titles were executed over long periods of time. The first remained uncompleted, while the existence of the second was divulged only after Duchamp's death in October 1968. Today, the Philadelphia Museum of Art houses them, as well as many other Duchamp works, which makes it the most important museum collection of his art.

The Bride Stripped Bare By Her Bachelors, Even is too fragile to travel for exhibition purposes, and it has been rebuilt several times. One of the men who has reconstructed it, the artist Richard Hamilton, has written a clear and concise report on the generation and execution of *The Large Glass*, which grew out of his attempts to understand and reproduce it.[42] This is recommended reading for anyone looking for a point by point recapitulation of each individual detail. In his chapter on *The Large Glass*, Robert Lebel suggests that Duchamp did not commit himself to an inflexible concept, but was always tinkering around on the work, so that sometimes meanings overlap.[43] To focus our understanding of his intent at least somewhat, Duchamp published three boxes of replicated notes over the years, which are relevant to *The Large Glass*, as well as to his readymades and *Etant donnés*. Each box has its own title, and each was produced in an edition, similar to graphic works or books (the *Box of 1914*, p. 34), the *Green Box* and the *White Box*).

All three boxes of these notes were reprinted in Sanouillet and Peterson's book mentioned above. They suggest ideas and images, nullify others, and weave a network of co-ordinates for locating the impulses behind the bride, the bachelors, their machinery and witnesses. Perhaps

PAGE 72:
Monte Carlo Bond, 1924
Obligations pour la roulette de Monte-Carlo
Photocollage with a photo of Marcel Duchamp by Man Ray on colored lithograph,
31.5 x 19.5 cm
Milan, Collection Arturo Schwarz

Duchamp founded a society for a game of chance – roulette – and sold bonds for 500 francs each to finance his playing. He had developed a special system that he thought would make profit possible. The face of the bond uses a Man Ray photo of Duchamp with a lathered head, his hair sculpted into the winged head of Mercury, the Roman god of commerce and science, and patron of thieves and vagabonds.

Francis Picabia
Portrait of Cézanne, c. 1920
No longer extant. Printed by Cannibale (Paris), 25 April 1920

A lost work of Picabia using a stuffed monkey, the traditional symbol of the painter as an imitator of nature, on the one hand, and of vice and sin, on the other hand. Both a still life and a portrait, this work is not exactly a flattering reference to the artists in question.

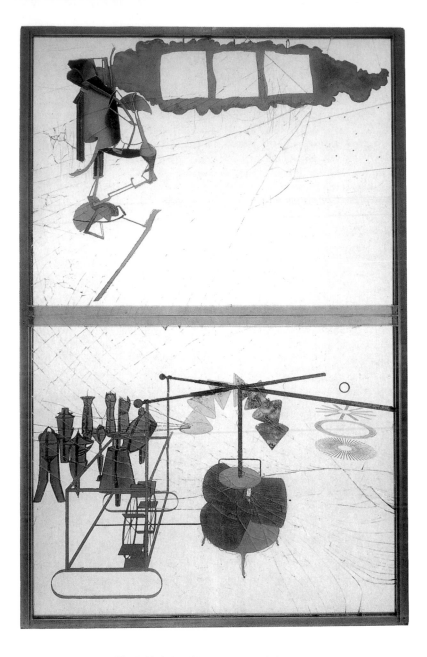

The Bride Stripped Bare By Her Bachelors, Even
or **The Large Glass**, 1915–23
Oil, varnish, lead foil, lead wire and dust on two
glass plates mounted with aluminum, wood and
steel frames, 272.5 x 175.8 cm
Philadelphia (PA), Philadelphia Museum of Art,
Bequest of Katherine S. Dreier

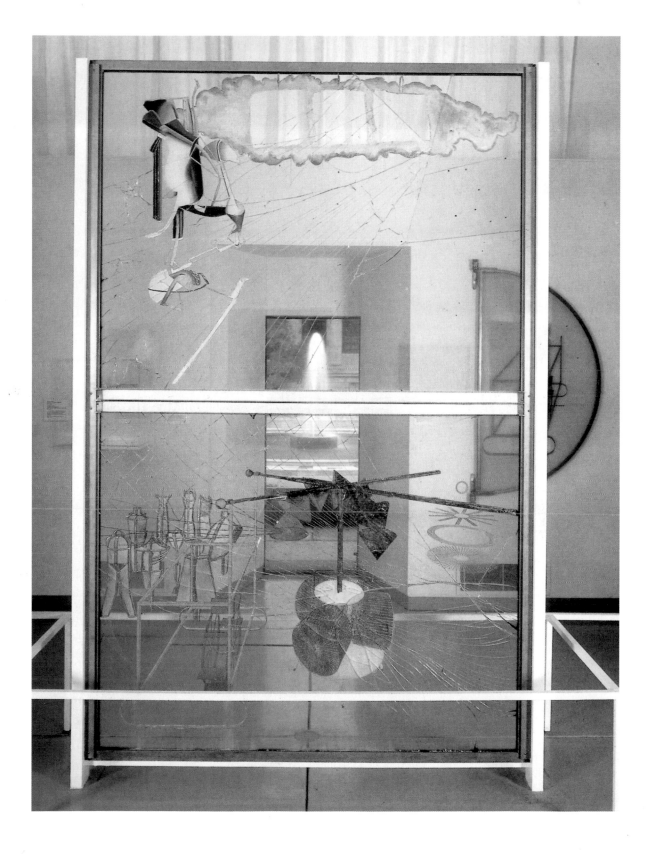

Barbara Dilley, Gus Solomons Jr., Carolyn Brown, Marcel Duchamp and Merce Cunningham, David Behrmann and Sandra Nils at the first performance of Cunningham's *Walkaround Time*, stage design by Jasper Johns using motifs from Duchamp's *The Large Glass*, Buffalo, New York, 10 March 1968 Photograph by Oscar Bailay, New York, Courtesy of Cunningham Dance Foundation

PAGE 75:
The Large Glass, 1915–23
Installation in the Philadelphia Museum of Art

while looking at the *The Bride Stripped Bare By Her Bachelors, Even*, the viewer should take to heart the advice that Duchamp once gave to his own bride when she asked him about the meaning of Picabia's wedding gift, an artwork (to everyone's surprise, Duchamp was married briefly for three months in 1927): "An artist expresses himself with his soul, with the soul it must be assimilated. That's what counts."[44] Duchamp's belief in poetry is clearly still alive beneath his dislike of mindless art forms. While thinking about Duchamp's resurrection of the artist's soul, it is perhaps not irrelevant to note that in 1912, Odilon Redon made an oil painting of an architecturally framed, large stained glass window that flowers above a pietà (*The Cathedral*, Munich, Pinakothek).

The Large Glass is something like a department store window in size, and relates to the changing use of glass and metal in the architecture of the time. However, Duchamp uses it as a non-referential surface upon which some of the isolated components, such as the chocolate grinder and the glider, are shown with painstakingly convincing perspective. One is reminded of the disembodied reality reflected in store windows. Indeed, a note dated 1913 from the *White Box* deals exclusively with shop windows and ends with the comment, "No obstinacy, ad absurdum, of hiding the coition through a glass pane with one or many objects of the shop window. The penalty consists in cutting the pane and in feeling regret as soon as possession is consummated. Q.E.D." And also, "I. Show case with sliding glass panes – place some FRAGILE objects inside. – In-

convenience-narrowness-reduction of space, i.e. way of being able to experiment in 3 dimensions as one operates on planes in plane geometry."

The Large Glass has been called a love machine, but it is actually a machine of suffering. Its upper and lower realms are separated from each other forever by a horizon designated as the "bride's clothes". The bride is hanging, perhaps from a rope, in an isolated cage, or crucified. The bachelors remain below, left only with the possibility of churning, agonized masturbation. Duchamp invents the working parts of these two sexual machines, which are as arbitrary and absurd as the machinery of Roussel which inspired them. Their mechanisms are so complicated that they are usually accompanied by a diagram, which leaves the viewer feeling a little helpless. In an artistic essay without punctuation, someone named "davidantin" quite rightly wrote, "now duchamp takes fragments of science his relation to science is that of a scavenger you reach in and you say 'what a nice set of wires' and you pull them out and if you survive you say 'now doesn't that look great'... duchamp takes all sorts of physical laws they are physical laws in the sense that they are phrased like such laws this does this in such a way the feeble cylinders actuate the desire motor love gasoline you really don't know what he's talking about..."[45] Still, it is useful here to give a rough summary of their "functioning". Some additional ideas for the machinery were never carried out and exist only potentially in the notes.

The bride is made of several parts that supposedly work together like the parts of a motor. The motor runs on self-secreted love gasoline, inspired by Roussel's glass-caged worm, which created music with its metallic secretions. Despite her mechanization, the bride is also called the "arbor-type", recalling the young girl under the trees in Duchamp's painting, *Young Man and Girl in Spring* of 1911 (p. 18). The hanging figure, or "Pendu femelle", derives from the Munich *Bride* painting (p. 40). It has a "halo", which blossoms out into stripped flesh, coral-colored with a tinge of green. It corresponds to the comet's tail of the "headlight" child from Duchamp's 1912 car trip through the Jura mountains, namely his interpretation of the functioning headlight as a comet with, unusually, its tail in front. Here, the veil-like halo appears to protrude roughly from the bride's forehead. The headlight child was male; Duchamp compared him with Jesus, as the divine blossoming of his mother, with whom he was to be united, as well as with God. Since the notes refer to the bride's stripping as a cinematic blossoming, a halo and a milky way, it is clear that ideas are mixing here, as are the sexes of the bride and the headlight child. The flesh-colored protruding veil takes on explicit male qualities. The three wafting squares that so resemble the flat surface of the snow shovel in *In Advance of the Broken Arm* (p. 58) were derived from square sections of net curtain – one meter by one meter – that Duchamp had hung above a radiator and photographed as models. Although they have become soft like a veil, he called them "draft pistons", which also have male connotations in their mechanical functioning.

It is hard to say what the bride is doing, besides hanging and potentially lusting to the degree her "feeble cylinders" (notes) will allow. She does, however, have the potential of communication through inscriptions. Once again, the readymades come to mind. A so-called letter box of the alphabet provides the "hinge" between the vertical and horizontal parts of the bride. There letters could be found to form an inscription moving across the pistons towards the only sign of the bachelors within the bride's realm, namely the shots drilled through the empty right side of the pane.

PAGE 78:
Rotary Glass Plates (Precision Optics), 1920
Rotative plaques verre (optique de précision)
Five painted glass plates that rotate around a metal axis and appear to be a single circle when viewed at a distance of one meter, 120.6 x 184.1 cm and 99 x 14 cm (glass plate)
New Haven (CT), Yale University Art Gallery

Marcel Duchamp, Henri Marceau and a laborer during the installation of *The Large Glass* in the Philadelphia Museum of Art on 7 July 1954

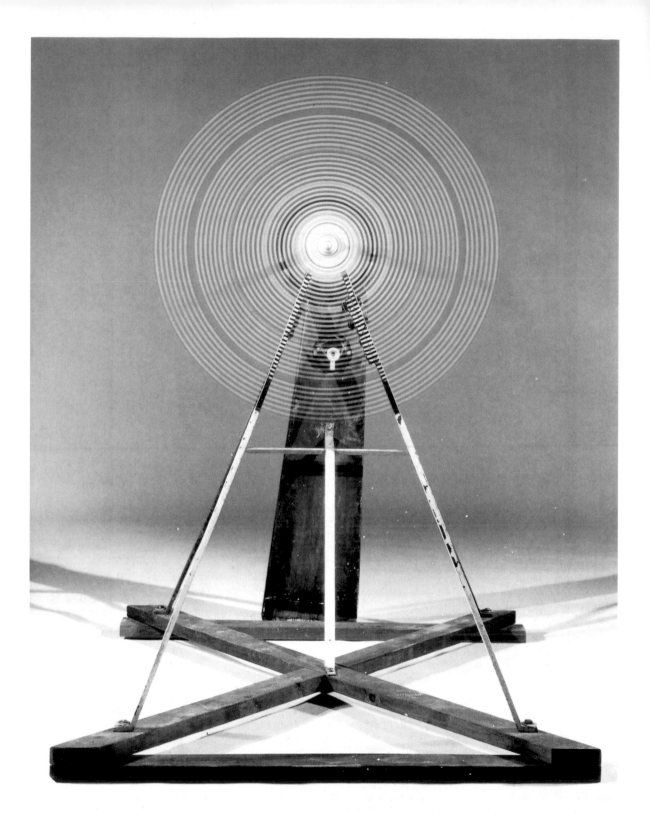

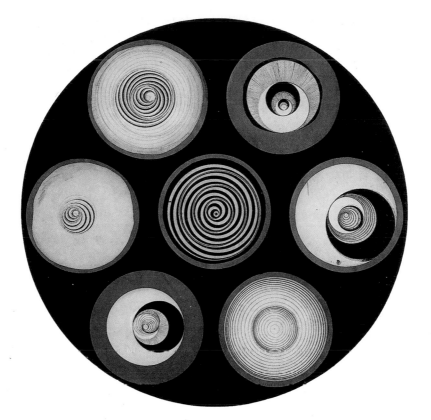

Disks Bearing Spirals, 1923
Disques avec spirales
Ink and pencil on seven irregularly cut paper disks, diameter from 21.6 to 31.7 cm, mounted on blue paper disks, in turn mounted on paper board, 108.2 x 108.2 cm
Seattle (WA), Seattle Art Museum, Eugene Fuller Memorial Collection

This was Duchamp's first motorized machine. When it rotates, the lines painted on the five plates appear as continuous concentric circles. Duchamp made several works experimenting with the effect of motion on perception. Man Ray tells an anecdote about one of Duchamp's rotating machines in his autobiography: "Besides devoting much time to chess, he was at the time engaged in constructing a strange machine consisting of narrow panels of glass on which were traced parts of a spiral, mounted on a ball-bearing axle connected to a motor. The idea was that when these panels were set in motion, revolving, they completed the spiral when looked at from the front. The day the machine was ready for the trial I brought around my camera to record the operation. I placed the camera where the spectator was supposed to stand; Duchamp switched on the motor. The thing began to revolve and I took the picture, but the panels gained in speed due to the centrifugal forces and he switched it off quickly. Then he wanted to see the effect himself; taking his place where the camera was, I was directed to stand behind where the motor was and turn it on. The machine began to revolve slowly, then gaining speed was whirling like an airplane propeller. There was a great whining noise and suddenly the belt flew off the motor or the axle and caught in the glass plates like a lasso. There was a noise like an explosion with glass flying in all directions. I felt something hit the top of my head, but it was a glancing blow and my hair cushioned the shock. Duchamp was very pale and ran to me, asking if I had been hurt. I expressed concern only for the machine, on which he had spent months. He ordered new panels and, with the patience and obstinacy of a spider reweaving its web, repainted and rebuilt the machine."

Vogue title page by Erwin Blumenfeld,
July 1945

In its July 1945 issue, *Vogue* took a look at the
Museum of Modern Art, where *The Large
Glass* was exhibited for a period of three
years (1943–1946). After the Second World
War, the Museum of Modern Art was able to
resume its full exhibition activity, and *The
Large Glass* briefly became one of the stars of
the collection. Duchamp's hanging bride
seems to have been replaced by *Vogue*'s more
earthly model, who looks down towards the
bachelors with slightly averted eyes.

Belle Haleine, 1921
Photocollage for a label of *Belle Haleine,
Eau de Voilette*, 29.6 x 20 cm
Milan, Collection Arturo Schwarz

The realm of the bachelors is even more complicated. There are nine
of them crowded together to the left behind a strange framework. They
look like hanging articles of clothing; only one bachelor has a tiny, wheel-
like head tilted back in perspective. Duchamp calls them "malic molds"
("malic" for "male"), assigns professions to them in their "cemetery of
uniforms and liveries" and says they are to be filled with illuminating
gas. They are connected to the rest of the machine by their ejaculations
that travel in gas form from their head-regions along "capillary lines".
These lines have been adopted from the *Network of Stoppages* (p. 48),
changed slightly so that they might be shown in perspective. Within the
"capillary lines", the gas changes into a solid that breaks into short
needles, which, in turn, ascend through the cone-shaped "sieves". These
sieves are colored by the dust that collected on their glass surface while
lying on the floor of Duchamp's studio for several months; a famous
photograph by Man Ray documents the "dust breeding" (p. 81). Duchamp

fixed the dust with varnish. During their passage through the sieves, the ejaculate "spangles" become liquid and spiral down into a great splash, the orgasm. At the same time, the strange framework signified as a "chariot", "glider", "sleigh" and "slide" is gliding back and forth on its runners, powered by an invisible waterfall turning the paddle-wheel. The right side of the framework is affixed with scissor-like bars that open and close with the movement of the "chariot". The chocolate grinder, resting on a round table with curving legs ("Louis XV chassis"), is connected to the threatening scissors at their joint. There doesn't seem to be any passage of energy here. As Duchamp suggested in his notes, the bachelor has to grind his chocolate himself. The "oculist witnesses" to the extreme right of the bachelors' domain personify the viewer.

Many questions remain open, not the least of which is why the bride has so many bachelors and not a single husband. The passage of time is also unclear, now after the shots that have pierced the bride's realm have rung out. Although the machinery of the bride and her bachelors has the potential for movement, nothing visible is happening anymore. Duchamp called the work a "delay in glass", which suits the atmosphere of waiting and stillness. All of the energy and juices of the proposed activities remain hypothetical or mythic. The full title is also puzzling. In French, the title ends with "même", which is always translated as the adverb "even". Of course, as has often been noticed, phonetically it could also mean "m'aime", that the bride "loves me". (This interpretation has supported an incest theory coupling Duchamp with his sister Suzanne.) It appears Duchamp added the "même" to the title after his arrival in the United States in 1915, when he was experiencing the disjointedness of the French language from the point of view of someone trying to teach it to Americans. If "même" were understood as an adjective (Duchamp himself said it was an adverb), it could mean "the same", such as "c'est la même chose" (that's the same

PAGE 82/83:
Box in a Valise, 1935–41
Boîte-en-valise
Cardboard box with miniature replicas, photographs and color reproductions of Duchamp's work, 40.7 x 38.1 x 10.2 cm
Edition of 300 unnumbered copies.
Paris, Musée National d'Art Moderne, Centre Georges Pompidou

Man Ray
Dust Breeding, 1920
Elevage de poussière
24 x 30.5 cm
Black and white photograph
Paris, Musée National d'Art Moderne, Centre Georges Pompidou

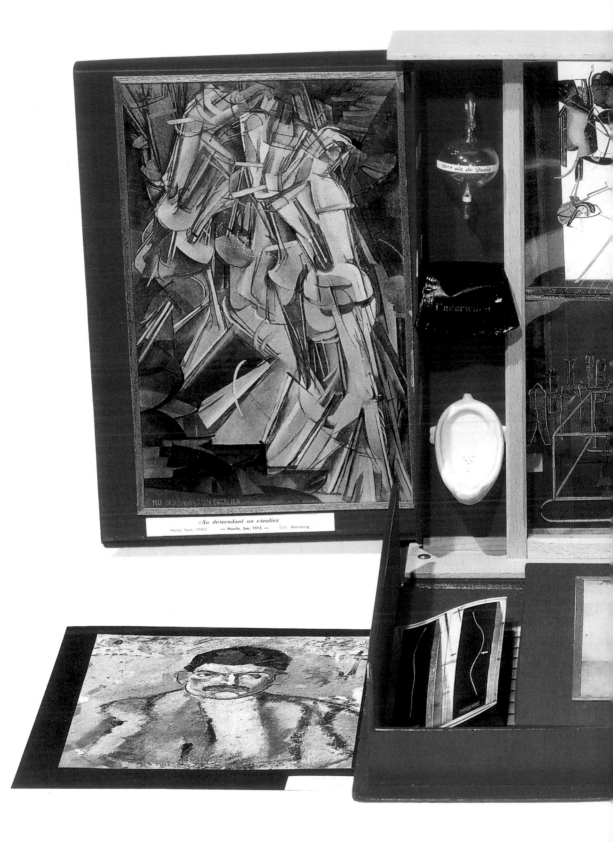

thing), "c'est moi-même" (it's me), or "quand plusieurs verbes ont un même sujet" (when several verbs have the same subject). In any case, it does seem possible that Duchamp hints the bride and the bachelors could be diverging facets of the single person who invented them.

No one is in the position of deciding what events determined Duchamp's psychological make-up. For the art historian, the most decisive aspect of his concentration on sexuality was its communicative potential as a universal human experience. Sexuality was for Duchamp a primary, a core element – that existential legitimacy all progressive artists were looking for at the beginning of the twentieth century. Lawrence Steefel, the art historian with whom Duchamp was perhaps most frank, was once told by the artist, "I want to grasp things with the mind the way the penis is grasped by the vagina."[46] Steefel has written: "Seeking to distance himself from his own fantasies, Duchamp sought a means of converting pathos into pleasure and emotion into thought. His mechanism of conversion was a strange one, but essentially it consisted of inventing a 'displacement game' that would project conflicts and distill excitements into surrogate objects and constructs without which his mental equilibrium might not have been sustained."[47] And Duchamp once said to Steefel, "I did not really love the machine. It was better to do it to machines than to people, or doing it to me." Steefel then adds, "By letting machines and mechanisms suffer outrageously, Duchamp could muster his energies for survival and the pursuit of poetry."[48] Duchamp's poetry remains unspoken as an atmosphere "between the lines"; it is always in the process of recreating itself through the mixing and overlapping of forms, ideas and emotions.

The Large Glass (pp. 74/75) originally belonged to Walter Arensberg, but when he moved to California, it entered Katherine Dreier's collection because the cross-country journey was believed too dangerous for the glass. For some reason, in 1926 it did travel to a show in Brooklyn, and both panes were shattered during its return trip to Katherine Dreier. Duchamp accepted the damage calmly and repaired it himself, growing to love the chance arcs that crossed over his imagery as if they were another incarnation of the *3 Standard Stoppages* (p. 46/47). His relationship to *The Large Glass* had been loose enough for him not to finish it; he simply stopped working on it in 1923. After that, he is said to have dedicated himself mainly to the game of chess, with peripheral performances in the sphere of art. From 1935 to 1940, he worked on replicating his works for a boxed "portable museum", which meant assembling photographs and supervising reproductions of his work. The pictures on glass were printed on sheets of transparent plastic, while three diminutive copies of readymades were also produced. Duchamp might well have been inspired by Gertrude Stein again, who had returned to the United States after many years in Paris for a sensational series of lectures. In her essay *Pictures* (1934) she had the following to say:

"There was a moment though when I worried about the Courbets not being an oil painting but being a piece of country in miniature as seen in a diminishing glass. One always does like things in little. Models of furniture are nice, little flower pots are nice, little gardens are nice, penny peep-shows are nice, magic lanterns are nice and photographs and cinemas are nice and the mirrors in front of automobiles are nice because they give the whole scene always in little and yet in natural colors like the receiver of a camera. As I say one does quite naturally like things in small, it is easy one has it all at once…"

Folding cardboard model of *Etant donnés*, part of Duchamp's installation instructions, 29.5 x 9.8 x 4.5 cm, c. 1966

The Bec Auer, 1968
Le Bec Auer
Etching on handmade paper, 50.5 x 32.5 cm
Milan, Collection Arturo Schwarz

After digesting his whole work in this way, and emphasizing the inter-relatedness of its separate parts within the microcosm of the box, instead of stopping, Duchamp was ready for something new.

His last work, a "peep-show", was entitled *Etant donnés: 1° la chute d'eau, 2° le gaz d'éclairage (Given: 1. The Waterfall, 2. The Illuminating Gas)*, here shortened to *Etant donnés* (pp. 85–89), and was carried out in great secrecy in New York over a twenty-year period. (One person who knew of the work and helped him was the woman he married in 1954, Teeny Duchamp.) The title comes from one of his working notes published in the *Green Box*. Although this indicates that it has come from the same source of ideas as did *The Large Glass* and the readymades, it is as shocking and immediate as *The Large Glass* is hermetic and distanced. In his last work, Duchamp wanted to be sure of two things: that the hidden eroticism of *The Large Glass* would turn into overt sexuality, and that the viewer would be more aggressively challenged to leave his or her view-

View through the door of the installation:
Given: 1. The Waterfall, 2. The Illuminating Gas, 1946–66
Etant donnés: 1° la chute d'eau, 2° le gaz d'éclairage

point as passive recipient and actually become aware of the threat of sentience. *Etant donnés* is a diorama whose subject-matter often results in it being compared to a peep-show. However, it has just as much in common with a lifelike exhibit in a Natural History Museum, where a deceased wildlife specimen is stuffed and shown in a three-dimensional set-up of its natural surroundings before a painted background.

Despite its size, it is quite possible to miss seeing *Etant donnés*. The viewer going through the collection of the Philadelphia Museum of Art will eventually reach a room that appears to be empty. On one wall there are a pair of old, very worn wooden doors without a handle, surrounded by brickwork. Only if the viewer gets closer to admire the patina of the old wood, or somehow becomes curious about the closed doorway, will he or she notice two tiny holes around eye level. A cursory look through the holes rivets the viewer, evoking a strong feeling of alarm and helplessness. There, directly before one, is a stripped female body lying on its back, a heavy or swollen-looking woman whose long, messy blond hair has fallen across her face, disguising her identity. She has been left for dead in an overgrown clearing, yet she manages to hold aloft a glowing gas lamp with her one visible arm. Her legs are spread wide apart, with one foot so close to the viewer that it is not contained within the diorama. It is this leg stretching towards the viewer that pulls his or her eyes directly towards the figure's open crotch. Duchamp has dispensed with her pubic hair and genitals, so that only an indentation is visible between her legs. Although she is obviously a woman, she has been strangely desexed and somehow abused, without a bruise on her. In the background a watery landscape atmospherically reminiscent of that of the Mona Lisa suggests a distant and deserted corner of the earth – a source, but not a pure or unequivocal one. (Duchamp had recently rehabilitated the Renaissance painting by "shaving" the Mona Lisa.)

There is no precedent for such brutal representation of reality in Duchamp's work, even though its components seem familiar, for example, the stripped woman who accompanied his work since *Dulcinée* (p. 23),

PAGE 88:
Given: 1. The Waterfall, 2. The Illuminating Gas, 1948–49
Etant donnés: 1° la chute d'eau, 2° le gaz d'éclairage
Painted leather on plaster relief, 50 x 31 cm
Stockholm, Moderna Museet

View from the back of *Etant donnés*. Duchamp's last major work was carried out in complete secrecy. He tinkered around with it and continually improved it over a period of about twenty years. The art world had assumed that he had more or less given up making art. The assemblage is handmade in a complex, highly detailed fashion. For example, the female figure is covered with fine leather to make the skin appear as realistic as possible.

Water & Gas On Every Floor, 1959
Eau & gaz à tous les étages
Imitated Readymade: enameled plate
(15 x 20 cm) on the cover of the de luxe edi-
tion of Robert Lebel's *Sur Marcel Duchamp*
Paris, Collection Jean-Jacques Lebel

or the *Bec Auer* gas lamp of the type sketched by Duchamp as a boy. The
two givens – the waterfall and the illuminating gas – also play a role in
The Large Glass. In 1958, Duchamp cited them again on the cover he
designed for the deluxe edition of Robert Lebel's Duchamp monograph:
Eau & gaz à tous les étages (*Water & Gas On Every Floor*; (p.90) was
an imitated Readymade that looked like the enamel signs affixed to
apartment buildings in late nineteenth-century France. It must have been
amusing for Duchamp to use the "omnipresent" Readymade to refer to
the still secret and uncompleted *Etant donnés*, in a gesture that was per-
haps similar to his hanging readymades on a gallery coatrack in 1916.

He referred to *Etant donnés* again with a strange etching executed in
the year of his death (p.86). The outline drawing in the etching shows

almost exactly as much of the female figure from *Etant donnés* as the viewer can see through the peek-holes in the wood. However, in the etching, the woman is not alone. Her right shoulder and upper torso disappear behind a nude male companion, united with him somewhat like the two kissing figures at the lower right in Matisse's painting *The Joy of Life* (p. 19), which Duchamp had already used once as a partial inspiration for *Young Girl and Man in Spring* in 1911 (p. 18). In Duchamp's etching, the man is practically pillowing himself on the woman's abdomen, with his hands folded behind his head. Yet, in contrast to the Matisse couple, there is a feeling of distance between Duchamp's figures, as if a particular man were relaxing and considering a generic female, who remains unresponsive, even numb. Of course, the image is also humorous, since the Bec Auer gas lamp corresponds to the other implied erect element of the composition, which the viewer cannot and ought not to see.

The etching seems to show a correspondence or union between the two figures, although it is not the customary erotic joining that Matisse shows. However, if the viewer completes Duchamp's line drawing in his or her

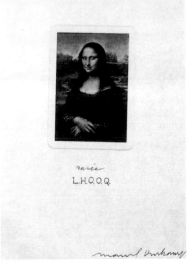

L.H.O.O.Q., shaved, 1965
L.H.O.O.Q., rasée
Invitation card, 21 x 13.8 cm
New York, The Museum of Modern Art

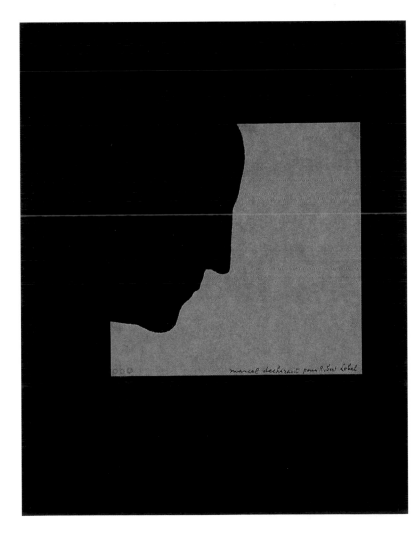

Self-Portrait in Profile, 1958
Torn colored paper on black background,
14.3 x 12.5 cm
Paris, Collection Jean-Jacques Lebel

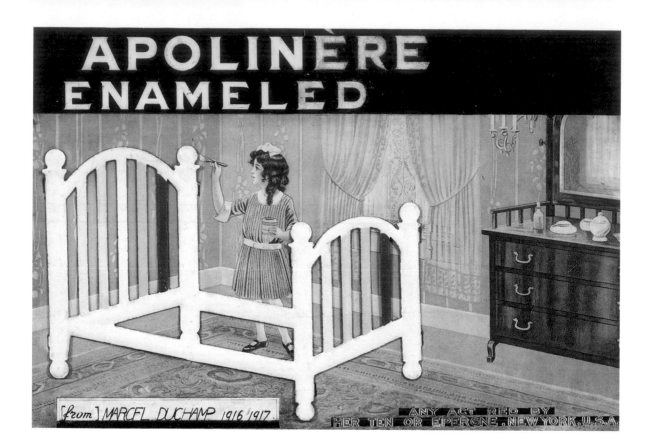

Apolinère Enameled, 1916–17
Rectified readymade, painted enamel sign,
23.5 x 12.5 cm
Philadelphia (PA), Phialdelphia Museum of
Art: Collection Louise and Walter Arensberg

mind, energy dances in a circle along the lines of the man's arms, up to the lamp, across to his (imagined) erection and back to its starting point at the center of the image, the man's dark head. The back of his head and the female figure's crotch are curiously aligned. At the same time, his interest is not directed at her genitals, nor apparently at his own. His back excludes any audience from entering the image, making clear that the viewer of the etching is the voyeur. In the diorama of *Etant donnés*, the male half of this union has withdrawn. The viewer is surprised again into the role of voyeur – and this author finds it a very bitter one for the female audience. Duchamp violates the female body, but he is just as obviously using it in a metaphoric way.

In 1916–17 in New York, Duchamp found a small enamel sign advertising the Sapolin brand of paint, which he touched up slightly, turning it into the readymade *Apolinère Enameled* (p. 92). Duchamp changed the lettering and couldn't resist putting the little girl onto glass by penciling the back of her head onto the mirror over the commode as a reflection. Another reference to the *Bride* exists in the title, which recalls the snow shovel in the readymade *In Advance of the Broken Arm* (p. 58) when pronounced with an American accent: "A pole in air". Duchamp must have enjoyed the sexual innuendoes in the advertising image of an innocent girl serenely brushing the stalwart bedpost with her wet little brush. As the lettering to the lower right suggests, she has something to do with "any act red", meaning perhaps the color, passion or readability, or

what is more likely, something between all those things. In *Apolinère Enameled*, Duchamp had also dedicated a work to his Parisian acquaintance, the poet and critic who had made Duchamp the subject of the last chapter of his book about Cubist painters. However, in *Apolinère Enameled*, not only the mattress, but also the man is missing from the work that names him with its inscription. Duchamp found someone who was not there. Similarly, by first publishing the etched version of *Etant donnés* including a male figure, Duchamp drew attention to its omission in the diorama, which was made public only after his own physical departure from this world. In a way, the abandoned woman of *Etant donnés* is Duchamp as an empty bed, or better yet, Rrose, the femaleness he wanted to reach.

Among other things, Apollinaire wrote as early as 1913 that Duchamp was trying to create an art "directed to wresting from nature, not intellectual generalizations, but collective forms and colors, the perception of which has not yet become knowledge".[49] Although no longer a "Cubist" painter concerned with colors and forms, at the end of his life Duchamp's goal does not seem to have changed. While negating the body of art, he upheld its poetic spirit. He tried to cage the undefined, to use this world in search of its projection into the next, to harness the illumination of eroticism. In other words, why not sneeze?

Sonett II

Surgi de la croupe et du bond
D'une verrerie éphémère
Sans fleurir la veillée amère
Le col ignoré s'interrompt.

Je crois bien que deux bouches n'ont
Bu, ni son amant ni ma mère,
Jamais à la même Chimère,
Moi, sylphe de ce froid plafond!

Le pur vase d'aucun breuvage
Que l'inexhaustible veuvage
Agonise mais ne consent,
Naïf baiser des plus funèbres!
A rien expirer annonçant
Une rose dans les ténèbres.

Stéphane Mallarmé, 1887[50]

Chronology

The house of the Duchamp family in Blainville, 1890–1900

1887 Henri-Robert-Marcel Duchamp is born near Blainville, Normandy, on 28 July, the third of seven children in what is an upper middle-class family; his indulgent father is a notary. Duchamp's mother is rather distant and unresponsive. The family home is decorated with engravings and paintings done by Duchamp's maternal grandfather.

1902 Duchamp begins painting.

1904 Finishes school and joins his elder brothers in Paris. Enrolls in art school, but spends most of his time playing billiards.

1905 Duchamp draws cartoons for newspapers. Finishes military service, and is exempted from second year of service through being employed as an "art worker".

1910 Most important early works showing influences by Cézanne and Fauvist painters.

1911 Overtones of Symbolism, Cubism and Futurism in his work. Influenced by chrono-photographs. Executes chess player paintings. Also *Sad Young Man in a Train* (a self-portrait) and oil sketch for *Nude Descending a Staircase* First machine painting – *Coffee Mill*.

1912 A year of turning points. Paints *Nude Descending a Staircase*, which he is asked to

withdraw from the Salon des Indépendants. Attends opening of Futurist exhibition at Bernheim-Jeune Gallery and returns several times. The chess paintings develop into *The King and Queen Surrounded by Swift Nudes*. Friendship with Picabia and Apollinaire, with whom attends Raymond Roussel's *Impressions d'Afrique*. Visits an acquaintance in Munich for two months. Trip by car to the Jura mountains with Picabia, Picabia's wife and Apollinaire. Duchamp begins to write notes and save them.

1913 Employed as a librarian at the Bibliothèque Sainte-Geneviève, Paris. Begins mechanical drawings, oil studies and notations that will result in the complex work, *The Bride Stripped Bare By Her Bachelors, Even (The Large Glass)*. Mounts a bicycle wheel on a kitchen stool. Executes the work that helped him break away from art as it was known until that time: *3 Standard Stoppages*.
In New York, *Nude Descending a Staircase* creates a scandal, making Duchamp famous.

1914 Buys a bottle rack at a Paris department store and puts it in his studio. Publishes the first box of replicated notes.

1915 Arrives in New York on 15 June. Meets patrons Walter and Louise Arensberg. Made to feel welcome in the land of Charlie Chaplin and Buster Keaton films, excellent plumbing, and astoundingly engineered bridges and skyscrapers.
Meets Man Ray, who becomes a lifelong friend.

1916 Coins the term "readymade". Two readymades shown at the Bourgeois Art Gallery, New York, by simply hanging them up on the coat rack.

1918–19 Trip to Buenos Aires, where he remains and joins chess club, referring to himself as a "chess maniac".
Returns to Europe, visiting family and establishing contact with Dada group in Paris.

1920 Returns to New York, bringing the readymade *50 cc of Paris Air* back as a present for Walter Arensberg. Works on *Rotary Glass Plates (Precision Optics)*, a motor-driven construction for experimenting with optical effects. Photographed by Man Ray as *Rrose Sélavy*.

1923 Stops working on *The Large Glass*. Serious training for professional competition in chess tournaments.

1924–34 Travels, participates in chess tournaments, co-authors book about chess problems.

1934 Publishes the *Green Box* of replicated notes and sketches.

1935 Produces set of six *Rotoreliefs*, to be used on a rotating record player. Sold for three dollars a set.

1941 Official date of first publication of *Box in a Valise*, a representative selection of his work in miniature reproductions, packed up in a fold-out box.

1946 Begins work on last major work, *Given: 1. The Waterfall, 2. The Illuminating Gas*, which lasts 20 years.

1954 Marries Alexina (Teeny) Sattler, who had previously been married to Pierre Matisse.

1964 Galleria Schwarz, Milan, produces thirteen readymades in an edition of eight signed and numbered copies.

1967 Publishes box of notes *In the Infinitive (White Box)*.

1968 Dies on 2 October and is buried in Rouen.

1 "Marcel Duchamp" in: *Marcel Duchamp*, The Museum of Modern Art and Philadelphia Museum of Art, Anne d'Harnoncourt and Kynaston McShine, eds. (a collection of various essays and catalogue of the Duchamp collection of the Philadelphia Museum of Art), p. 295

2 Thomas Zaunschirm, *Bereites Mädchen/Ready-made*, Klagenfurt, 1983, p. 127 f.

3 Excerpts from poem *Lifting Belly*, 1915–1917, Gertrude Stein, reprinted fully in: Zaunschirm (see note 2 above), also in: *The Yale Gertrude Stein*, New Haven and London, 1980

4 Walter Pach, *Queer Thing Painting, Forty Years in the World of Art*, London, 1938, p. 163

5 "Marcel Duchamp" in: *Ingénieur du temps perdu. Entretiens avec Pierre Cabanne*, Paris, 1967, p. 34

6 ibid., p. 9

7 Guillaume Apollinaire, "Watch out for the Paint! The Salon des Indépendants – 6,000 Paintings are exhibited", in: *Apollinaire on Art: Essays and Reviews 1902–1918*, Leroy C. Breunig, ed., New York, 1972, p. 71

8 See note 1 above, p. 245

9 See note 5 above, p. 49

10 ibid., p. 52

11 Marcel Duchamp, interview with James Johnson Sweeney, in: *Salt Seller – The Writings of Marcel Duchamp (Marchand du Sel)*, Michel Sanouillet and Elmer Peterson, eds., New York, 1973, p. 126

12 See Marcel Duchamp, Palazzo Grassi exhibition catalogue, Venice 1993, Ephemerides on Marcel Duchamp and Rrose Sélavy, 1887–1968, compiled by Jennifer Gough-Cooper and Jacques Caumont, dated from 10 June 1912

13 Magazine *Le Théâtre*, bound volume exhibited in a glass case in the above exhibition, p. 23 (1912?)

14 See note 5 above, p. 56

15 See note 11 above, p. 30

16 Raymond Roussel, *Afrikanische Impressionen*, Munich 1980 (author's English translation)

17 Marcel Duchamp, interview with Russell, printed as *Exile at Large* in: *The Sunday Times*, London, 9 June 1968, p. 236

18 Wassily Kandinsky, *Über das Geistige in der Kunst. Insbesondere in der Malerei*, Munich 1912. Quoted here from "On the Spiritual in Art" in: Kandinsky, *Complete Writings on Art 1901–1942*, Kenneth C. Lindsay and Peter Vergo, eds., London, 1982, p. 130

19 Rose Lee Goldberg, *Performance – Live Art 1909 to the Present*, New York, 1979, p. 34

20 See note 12 above, 1 July 1912

21 ibid., 7 August 1912

22 Gabrielle Buffet-Picabia, "Some Memories of Pre-Dada: Picabia and Duchamp" (1949) in: Robert Motherwell, ed., *The Dada Painters and Poets: An Anthology*, New York, 1951, p. 257

23 See note 12 above, p. 34

24 ibid., p. 36

25 See note 11 above, p. 160

26 Guillaume Apollinaire, *Les Peintres Cubistes*, Paris, 1913; quoted here from: Herschel B. Chipp, *Theories of Modern Art*, Berkeley, Los Angeles and London, 1968, p. 246

27 Herbert Molderings, *Marcel Duchamp – Parawissenschaft, das Ephemere und der Skeptizismus*, Frankfurt a.M./Paris, 1987, pp. 35–37. Quoted here from "Objects of Modern Scepticism" in: *The Definitely Unfinished Marcel Duchamp*, Thierry de Duve Cambridge (MA) and London, 1991, pp. 244–245

28 ibid.

29 See note 27 above, p. 246

30 See note 1 above, p. 272

31 ibid., p. 270

32 See note 27 above, p. 248

33 See note 22 above, p. 260

34 H.-P. Roché, "Erinnerungen an Marcel Duchamp" in: Robert Lebel, *Duchamp – Von der Erscheinung zur Konzeption*, Cologne, 1962, pp. 168–169

35 Roger Shattuck, *The Banquet Years – The Origins of the Avant-garde in France 1885 to World War I*, New York, 1968, p. 7

36 Marcel Duchamp, quoted in: Dieter Daniels, *Duchamp und die Anderen*, Cologne, 1992, pp. 168–169

37 Martin Kunz, *Marcel Duchamp – Wirkungsgeschichte des "Ready-made" zwischen 1913 und 1919*, Basle, 1975, pp. 12–13

38 Dieter Daniels, see note 35 above, p. 178

39 *The Blind Man*, No. 2, May 1917, New York

40 See note 5 above, p. 111

41 See note 11 above, p. 103

42 Richard Hamilton, *The Large Glass*, see note 1 above, p. 57

43 Robert Lebel, see note 33 above, p. 93

44 See note 12 above, 8 June 1927

45 davidantin, "Duchamp and Language" in: *Marcel Duchamp*, see note 1 above, p. 112

46 Marcel Duchamp to Lawrence D. Steefel, Jr., quoted in: Arturo Schwarz, *The Complete Works of Marcel Duchamp*, London/New York, 1969, p. 114

47 Lawrence D. Steefel, Jr., "Marcel Duchamp and the Machine", in: *Marcel Duchamp*, see note 1 above, p. 70

48 ibid., p. 71

49 See note 26 above, p. 245

50 Stéphane Mallarmé, *Œuvres complètes*, Coll. La Pléiade, Paris, 1945, p. 74, Translated as: Sprung from the leap and the croup of a glassware ephemeral flowering no bitter vigil the neck forgotten stops Sylph of this cold ceiling, I well believe two mouths never, neither mother nor her lover, drank the same fantasy! The vase pure of any potion save the widowhood unspent dies but does not consent, naive kiss of the most dour! to breathe an annunciation of a rose in the obscure.

Collection Arturo Schwarz, Milan: 13, 16, 25, 51, 59, 80
Photograph © 1994 The Museum of Modern Art, New York: 15, 46/47, 48, 69
Julian Wasser: 20
David Heald: 24
© Walter Klein, Düsseldorf: 39
Paul Macapia: 79
Oscar Bailay, New York: 76